PHOTOGRAPHY BEST SELLERS

One Hundred Top Moneymaking Stock Photos

JAMES ONG

FOREWORD BY JOHN DURNIAK

Moore & Moore
New York, NY

Table of Contents

Library of Congress Cataloging-in-Publication Data
Ong, James
Photography best sellers.
Includes index.
1. Photography, Freelance—Catalogs.
2. Photography, Commercial—Catalogs. I. Title.
TR690.2.054 1987 778.9'974167 87-16193
ISBN 0-942485-00-9
ISBN 0-942485-01-7 (pbk.)

Design: Ong & Associates, Inc.
Art Director: Joseph J. Kozak
Editor: Judith A. Posner
Writer: Gary Fishgall
Cover Photography: Ong & Associates, Inc.
Printer: Dai Nippon Printing Company, Ltd.
Distributor: Robert Silver Associates

Printed in Japan.

Published by:
Moore & Moore Publishing
485 Madison Avenue
New York, NY 10022
(212) 355-4808

George Glod: 1945-1986
Dedicated to the memory of George Glod,
an outstanding photographer and, especially, an
outstanding person. Quiet...polite...uniquely
sensitive, truly a "gentle man"...and
a very good friend.

Foreword

*One Hundred Solutions
in Search of Problems*

Two million dollars' worth of stock pictures are in this book. Those surprised by this revelation shouldn't be. Strong signals have appeared over the last twelve years indicating that stock photography is a fast-moving growth industry. The power of stock photography comes from the age in which we are living. Ours is a communication-oriented society. Messages are being beamed and sent to us by the thousands, with every tick of the clock, around the clock.

Automobile manufacturers in Tokyo, Detroit and Stuttgart use pictures to sell cars; the United States government wants young men and women to join the military services, and entices them to do so with visual messages; a Wall Street firm does the same to take a reader's dollars and make him more money. Message after message hits us. We are surrounded by words and pictures, many of them stock pictures.

Stock photography—the system of finding solutions instantly through ready-made pictures—is here in full blossom. It is big business exploding into bigger business thanks to the computer's potential as a graphic tool for design and storage. The stock photography file will become an electronic swipe file with a difference: One can buy those color-rich pictures instead of commissioning them. Now, what you see is what you get. If the picture works, one can have it immediately for layout and publication use.

In this age of the image, we take for granted that all communications will automatically be accompanied by photographs. Today, a message without a picture is odd, out-of-place, unnatural. A message without supporting images may also be less effective in getting the viewer to understand what is being said.

Words rarely stand alone in advertising in our time. Pictures do a good job that words cannot do. Words and pictures together are a powerful force. If one wants to test this premise, just cut the captions off the news pictures or blackout the lines in ads. Pictures alone and words alone are less than words and pictures working together. Pictures help conjure up stories in the mind. Some pictures suggest stories with a beginning, middle and end. Some pictures are cliffhangers leaving the viewer to guess what might happen.

The pictures in this book have one important element in common—they're ambiguous. However, they can easily be made specific by the addition of words. A second picture, inserted or used on an opposite page, can define the image. A supermarket of products and concepts can be brought to an abstract image, shaping that image into new meaning. Such images are important grist for the message mill.

It has been said of radio that the listener is given the words and makes up the pictures in his own mind. Of pictures, the opposite can be said. Pictures produce the people, places and products— and the mind produces the words and story. Themes and subjects found in these images are those that concern most advertisers today. Such images are planned and do not happen by accident. As a result, images from such preparations are more marketable.

Subject matter is extremely important in stock photographs. These pictures reflect the change in our society: Blacks taking new responsible positions in American life; the development of high technology; women finding themselves in executive positions; the creation of a new class of young professionals with money to spend; and a society that travels more, is health- and style-conscious. Stock photographers respond to the needs of our time in the subjects they shoot.

Pictures are the clay of communication. Their form, structure and meaning can be changed instantly by the way they are used. For example, have you ever watched a talented picture editor or great art director work with a set of pictures like those in this book? Each arrives with a problem to solve. They have the message and know how to communicate it. Some have preconceived notions of what the solution is, but most are open-minded and want the adventure with serendipity.

Suddenly, they come across an image. The hand of the designer reaches for translucent paper, and words are sketched in an open area of the photograph. The photograph is like the top seller in this book—a bright light breaking through the cloud symbolizing a new day. The words sketched in read: "To touch tomorrow." The picture stops the eye…the message hits the mind. It is the beginning of a powerful advertising message.

Next, the message is picked up and tried on the picture that shows business people walking up the stairs at sunset, getting on a jet plane. "To touch tomorrow" are the words, but now the message is different, because the image has changed. Tomorrow, each person may be in a different place. What help will they require to deal with the coming day? The reader, most likely, will read on to find the answer.

After flipping through more pages, the words are superimposed over the NASA shot of the world floating. Now, the message takes on gigantic proportions. Will the message be about "me" and "the universe?" Keep reading and find out.

Another different image is found— children running hand in hand on a summer's day. Suddenly, "to touch tomorrow" wakes new ideas and the message is sketched to the top right over the little girl's head. It's probably about growing up, about young families, about learning, about insurance.

For the creative visual mind, a collection of stock photographs can be an amazing coloring book with which an art director can try out his or her ideas. It is only as good, or poor, as the mind that uses it. It is both a tool and a mirror. It is a workshop where visual experiments can be tried without spending great amounts of money. Can this book of stock photographs save money? Let's look at it this way: Most photographers shooting today charge between $350 and $2,000 a day. Setting up and shooting each of the images in this book took from one to three days, depending on the difficulty and accessibility of the subjects. The cost to a client for a selection of this scope would cost between $35,000 and $200,000.

Clever advertising men have been able to do entire campaigns without ever having an art director or photographer leave the office…simply by doing all the work using stock photography. Is the photographer getting cheated? No! Stock photographs today are blue-chip earning devices. Top photographers can earn as much as two-thirds of their income from the stock shots they have taken.

Is the stock photographer different from the assignment photographer? Actually, most photographers do both. Those who shoot mainly for stock are pragmatic businesspeople as well as creative artists. The stock photographer can have the qualities of an Ansel Adams or an Avedon, but his marketplace is definitely different. This marketplace influences what and how he shoots. He is aware of what sells and stocks his shelves with these images.

The stock photographer never stops searching for visuals and takes his camera into the most intimate moments of his life. His (or her) family pictures made at the birth of his baby become ads, and pictures shot at a family barbecue dinner become roadside billboards. He is also a gambler who will take a trip or a vacation to make unusual pictures as he goes…all for his stock files. Everything a stock photographer sees and shoots is potential material for his files. What makes a talented photographer stop, look and shoot will also make a viewer stop, look and react. In technical quality and picture-making ability, stock photographers can rank with the best.

Stock photographs are raw images waiting for a creative art director to unite them with words and send them out to sell products. Some of these stock images will be used purely as eye-catching decorations, some will become subtle backgrounds, while others will be partners with words. Some will be chosen only for their color to attract the eye promenading through a magazine.

In commercial photography, strictly aesthetic qualities are second to the photograph's power to sell. Surveys are constantly being conducted by advertising agencies seeking to learn how pictures influence purchasing judgments. Recently, the advertising community spent over a quarter of a million dollars on a survey ("The Comprehension and Miscomprehension of Print Communications") to try to learn if the messages were working. The results: 37 percent of the people exposed to magazine ads and articles do not comprehend them. Ads, however, are better understood than articles, and one of the assumptions is that the better use of images and graphics in ads make their messages easier to understand. Yes, good photographs with good graphics make it easier for a viewer to understand what is being said.

What helped make the stock photographs in this book a success? These images sell to the world of advertising, publishing and corporate communications because they catch the attention of the art director and picture editor, and because each of them has the power to evoke a response from the viewer. These are working pictures. They work for the photographer, for the ad agency and for the client. They work for the corporation and for the publisher. In years to come, stock photos will be increasingly recognized, appreciated and studied for their role in communications.

JOHN DURNIAK

Introduction

Stock photography is, quite simply, photography that already exists. It is typically maintained in the files of photographers and their agents to be perused...and used...by publishers, ad agencies, graphic designers and anyone else with a need for photographic imagery.

How many stock photos are there? No one has established an exact figure but, with hundreds of stock agencies in the United States, and many more in Europe and the rest of the world, and with hundreds of thousands of images retained by each, the total must be well into the multi-millions. Think of it: millions of stock photos all competing for audience attention!

Given this vast pool of images, the odds are slim that any particular photo will be selected for reproduction. So it's remarkable that those in this book have been acquired, not just once or twice but ten, fifty, eighty—even a hundred times—generating thousands of dollars a year for their creators, year after year.

It's hard to believe that an image—any image—could have such widespread appeal. Imagine, for example, using the same photo in an ad for a cruise line, in a brochure for a real estate company, on the cover of a paperback novel, in the point-of-purchase display for a fast-food restaurant and on the label of a vitamin package. The same photo! Taken by a photographer who didn't have any of these products and services in mind when the photo was shot.

Of course, the use of existing images isn't new—publishers have brought together unrelated texts and illustrations for centuries. But not until the last decade has existing photography been used so often. Or with such skill and variety. Indeed, art directors, editors and publishers today have become virtual masters at the art of communicating concepts through photographs that have no direct relationship to the ideas, products or services they are being used to sell.

The History of Stock Photography: A Brief Overview

While stock photography today is a multimillion-dollar-a-year industry, it began much more modestly in the late nineteenth century.

The earliest stock agencies can trace their antecedents to the peddlers in Europe's large commercial centers who collected prints and illustrations and sold them to publishers for reproduction in books and periodicals. When the positive-negative process that we think of as photography was developed in the 1840's, print peddlers, quick to see the new medium's commercial potential, added photos to their suitcases of wares.

Their principal customers—publishers—also grasped the opportunities presented to them through this new medium, one that captured news events, personalities and exotic places with unprecedented immediacy and fidelity. It is estimated, for example, that over 1,000 books with photos were printed during the 1850s. By the 1860s, photos had given rise to a new form of entertainment—the stereopticon, a hand-held instrument through which one viewed two identical images printed side by side on a card to give the effect of 3-D.

But, for over forty years, the use of photography in mass communications was restricted by the publishing industry's inability to print photos and type concurrently. To overcome this obstacle, some publishers produced text and image separately and then affixed the photographic reproduction to the printed page. But this was a slow and expensive process. Others had their images traced by etchers. But etching, an age-old practice that was well-suited to the adaptation of illustrations, proved cumbersome and inaccurate for photography.

Finally, in 1889, photoengraving was invented. This process, also called the "halftone" method, mechanically reduced the photographic image to a pattern of dots and at last it was possible to print photos and type simultaneously.

With the invention of photoengraving and the introduction one year earlier of George Eastman's Kodak—the first easy, portable camera—periodicals began to make extensive use of photography. By the early 1900s, publications, such as the *Illustrated American, Illustrated London News, Paris Moderne,* and *Berliner Illustrierte Zeitung* were interpolating documentary photos and photos of social activities along with the images of news events.

With the rapidly growing use of photography in publications, many print sellers ceased gathering prints entirely, concentrating instead on the new popular form of imagery.

Soon the size of their new collections prevented them from continuing to carry their wares door to door in suitcases, as they had done in the past. Instead, in the 1920s, they established libraries and, so that their customers could see what they had in stock, they published catalogs. Thus, the first stock photo houses were born.

Among the emerging stock houses in the United States was the H. Armstrong Roberts Agency. Credited with producing the nation's first stock photo catalog, Roberts initially specialized in movie stills and subsequently became known for its shots of cuddly babies. Another pioneering firm was the Ewing Galloway Agency. Founded by a former editor for *Collier's,* Galloway primarily used travel photographs to serve the needs of the textbook industry.

In the 1920s, the growing popular interest in photography and the introduction of the Leica, a new, fast-shooting 35mm camera, gave rise to large-format magazines including *Picture Post* in London, *Paris Match* in France, and *Der Spiegel* in Germany. Unlike their predecessors, these magazines relied on photos instead of words to tell their stories. Then, in 1936, the American version premiered. It was called *Life*—the largest and freshest picture magazine of them all.

Following the success of *Life* came other American picture magazines, *Look* and *Holiday* among them.

The picture magazines had an unprecedented need for photos, primarily for interrelated shots with captions that formed complete, self-standing stories.

The photo essay, or picture story as this genre came to be called, provided a tremendous opportunity for the early stock agencies. Many started generating their own story ideas. They assigned photographers, created captions and licensed the results on a non-exclusive worldwide basis. Of course, it didn't take long for these entrepreneurs to realize that, in addition to selling their photos as complete stories, they could market individual shots out of context as well.

In the 1930s, the rise of Facism forced the founders of several agencies—notably those in Germany—to immigrate to New York. Here in the publishing center of the United States, they established new companies, like Black Star and Globe, to continue the work they had begun abroad.

One of the refugees of Nazi Germany was Otto Bettmann whose vast archive of prints and early photos is world-famous. Another immigrant was Max Lowenherz whose collection, like Bettmann's featured non-photographic as well as photographic images.

During World War II, the picture magazine reached new heights, as photographers like Robert Capa and Carl Mydans brought the war into the homes of millions of readers everywhere. After the war, Capa and other noted photographers formed Magnum Photos, a photographers' cooperative which licensed the use of their images worldwide, a role that this renowned firm continues to play today.

Probably no development in this century advanced the general use of photography more than the widespread availability of color, nor has anything ultimately fostered a greater demand for stock. Inventors and camera buffs had been experimenting with the use of color since the 1860s, but it was Kodachrome, introduced to the marketplace by George Eastman in 1936, that provided the first high-quality, reliable color process.

Among the first to recognize Kodachrome's potential were the photo magazines, which started featuring color photos on their covers almost immediately. Within a short time, a few color images were appearing inside the magazines as well. Other types of printed materials also began to take advantage of this new technology—notably postcards, greeting cards and calendars.

But, despite the obvious appeal of color, black and white photography continued to predominate throughout the 1940s, '50s and '60s. The cost and length of time for color reproduction was simply prohibitive for most users. Then the invention of the laser color scanner and the development of presses especially for color printing lowered costs and shortened time-frames. These innovations, plus concurrent improvements in film processing and camera equipment made color better, cheaper and faster. And, as a result, the use of color photography skyrocketed—in books, magazines, ads, corporate communications materials.... everywhere.

At first, stock had been slow to appreciate the market potential of color. Only Shostal, founded in 1940, initially specialized in color photography. Most houses in the 1940s and '50s continued to stock only what was in greatest demand—black and white. However, by the early 1960s, with the technological innovations cited above, Shostal lost its preeminence in the field and most agencies cautiously added some color to their libraries. By the end of that decade, color so dominated the market that very few companies collected black and white photos anymore.

Ironically, as color became more accessible, the large national photo magazines, which had made such notable use of it, fell into decline. *Look* ceased publication as a weekly in 1971; *Life* a year later. However, they were soon replaced by a large number of special-interest magazines and these were almost insatiable in their need for color shots.

By then, the stock houses were ready to meet the demand.

Until the 1920s, advertising agencies served primarily as space brokers for their clients—with the clients writing the ads themselves. But, during the period of infatuation with American technology and industrial design that followed World War I, advertising agencies like J. Walter Thompson and McCann-Erickson became powerful image-makers for their clients and ultimately changed mass culture forever.

In the 1930s, advertising embraced photography. In fact, early commercial photography of the decade featured the work of some of the world's leading photographers, including Man Ray, Laszlo Moholy-Nagy, Cecil Beaton, Charles Sheeler and Edward Steichen. However, except for fashion photography, commercial work soon lost its appeal for artistic photographers. As a result, headlines and copy became the

adman's primary selling tools; photos were relegated to the illustrating of mundane product shots, simplistic usage demonstrations, portraits of company presidents and celebrities making endorsements.

Then came color. Color photography and advertising were made for each other. But the high cost of reproduction and the exigencies of World War II precluded agencies from seriously exploring the potential of color until the 1950s and '60s. Then, finally, advertising photography came into its own with the slick, sophisticated style so common today. From use in traditional print ads, color photography eventually expanded to include the full range of corporate communications—posters, point-of-purchase displays, packages and labels, annual reports, catalogs, brochures, mailers, etc.

With the emergence of a mature, readily identifiable style in commercial photography, the stage was set for a new type of stock photo agency—the type that Four By Five helped to pioneer.

Commercial Stock Photography

I entered the advertising field as an art director in the early 1960s. Soon thereafter, I started my own agency, Ong & Associates, which still exists today. At that time, stock agencies catered almost exclusively to the publishers of books, magazines, calendars and greeting cards. No agency had images with the slick, sophisticated look of advertising photography. So, like all the other ad agencies, we commissioned our own photography.

Then, in the early 1970s, I was designing an annual report for Kraft. I needed a farm scene. Essentially, any good image would have sufficed as long as it was immediately recognizable as a farm with

cows. So it made little sense to engage a photographer and scout locations just to capture this image. I was sure that someone would have that photo on file. We contacted every stock agency in New York, but finding that photo proved almost impossible, although eventually we did find something.

Given my experience, I naturally assumed that thousands of other art directors were finding an equivalent need for high-quality, existing photos and suffering the same frustrations. That's when I decided to establish Four By Five. Our firm and The Image Bank (another stock company founded at just about the same time) became the first to form libraries designed specifically for commercial photographic use.

In order to build our libraries, we couldn't wait passively for photos to come to us. At that time, photographers shooting for stock—and there weren't very many of them—lacked the slick, sophisticated style that we needed to attract advertising agencies and other commercial clients. So we did exactly what a previous generation of stock agencies had done to create photo essays—we hired our own photographers and commissioned our own assignments.

Initially, we encountered resistance from most ad agencies. Commercial stock photography didn't have a very good reputation at the time. It took about a decade to generally reverse this impression, but, at some of the larger agencies, it persisted until just a few years ago. Now almost every agency in the U.S.—and indeed the world—will consider using stock when an appropriate opportunity arises.

One of the primary reasons for our ultimate success with ad agencies lay in the subjects we decided to shoot. Because I was in advertising myself, I knew that most ads were inextricably linked to the interests and concerns of society as a whole, and that these factors were constantly changing. I believed that by anticipating future trends, we could offer ad agencies the images they needed when those trends became the basis for new campaigns. So we closely monitored the news, the demographic patterns of the day and other indicators of social, economic and political change and we shot images based upon the trends we saw emerging. Fortunately, our educated guesses proved correct. When agencies needed shots of middle-class blacks, for example, we were ready. We were also prepared with shots of women in the workforce and computerized office equipment when those images became popular.

Over time, as requests for photos from clients have increased, it's become easier to ascertain what subjects the market wants, but we still keep a close watch on changing societal patterns in order to anticipate future trends. With the addition of advertising agencies and corporations to the ranks of those who had been using stock for years—notably book and periodical publishers and the creators of greeting cards, calendars and other paper products—the market for existing photography expanded dramatically. And this market is increasing all the time.

Stock photography offers users several significant advantages. The first advantage is *convenience*. To organize an assignment, a photographer appropriate to one's needs has to be booked, a location selected, models interviewed and hired, schedules coordinated, travel reservations may have to be made and many other details orchestrated. For outdoor assignments, one may also have to wait for the right weather. Only after the shooting will the user see the results of the photo session. That could take days, weeks or even months.

By contrast, most stock photo agencies can have a selection of images awaiting review within twenty-four hours of the request. For periodicals, saving time may be a particularly significant factor. As a photo editor for a major magazine put it, "You can't take a picture yesterday. But you may be able to get it in stock today."

A second advantage—*choice*—logically follows from convenience. As one photo researcher recently told me, "Because of stock, I always find what I'm looking for. I wouldn't be able to exist if it weren't for agencies like yours."

In stock today, there are literally millions of images. In many instances, one can choose from hundreds or even a thousand shots of a particular subject. An image may be selected, tried and replaced if it doesn't work—reproduction rights are only paid upon actual use. By contrast, the user who engages an assignment photographer pays for the results whether he or she likes it or not.

Cost savings is another advantage—perhaps the most important in the opinion of many users. In today's economy, the expenses associated with any photographic assignment can be considerable, easily exceeding $10,000 or more if models and travel are involved. By contrast, the average reproduction fee for a stock photo is a fraction of that amount.

Creative inspiration is another, possibly less obvious, advantage of stock. Often, an art director may not have a strong visual concept at the start of a project. By examining stock photos—and most agencies will let art directors peruse their files if they wish—an appropriate image will emerge, trigger an idea and the rest of the creative process will fall into place.

In addition to these advantages—*convenience, choice, cost savings* and *creative inspiration*—stock photography offers users yet another advantage—*quality*. For decades, commercial stock photography was considered cliched, technically-simplistic and unimaginative. But "…in the past few years, the level of the quality of stock has risen," observed ASMP (The American Society of Magazine Photographers) in its *Stock Photography Handbook*. Advances in cameras, equipment, film development and computer technology have helped to improve stock photography, but the primary reason for the rise in quality has been the ability of the field to attract photographers of a higher calibre. Until recently, most photographers were oblivious to stock. Agencies had to solicit images from the personal files of amateurs and professionals alike by placing ads in photography magazines. As a result, photos which had been gathering dust for years in albums, boxes and desk drawers entered the field.

But over the last decade, this situation has shifted. Instead of agencies soliciting photographers, more often than not, photographers now solicit agencies. "I don't know any photographers who aren't shooting with stock in mind," one photographer said recently. Another told me, "When I began fifteen years ago, stock agencies would accept almost anything. Most photographers didn't even know what stock was. Today, only high quality originals will sell."

As a result, stock photography has become a highly competitive field. That's healthy. It provides photographers with a challenge. As one photographer told me, "Each time I shoot, I try to come up with something that will make my photo stand out among others on the same subject…so that mine will be the one users pick."

Today, some photographers even specialize in stock. The economic advantages can be considerable. With assignment work, a photographer will typically earn a single fee (unless the client extends his or her use beyond the terms of the original agreement and has to renegotiate), but a good stock image can last for a decade or more, producing steady income for the photographer in what we call a "photography savings account." Stock also gives photographers greater control over the use of their time—when not otherwise engaged, they can always go out and look for photo opportunities. "It sure beats hanging around the studio waiting for the phone to ring," one very prolific and successful stock photographer observed.

Of course, photographers on location for commissioned shootings can find photo opportunities for stock as well by shooting subjects in their free time that don't conflict with their assignments. You will find photos in this book that were the by-products of assignment photography. It's a smart way for photographers to make the most of their time and opportunities. While more and more photographers are specializing in stock or shooting with stock in mind, many photos still enter stock agencies via the personal files of good photographers who are simply shooting for their own pleasure. These individuals—amateurs as well as professionals—always have their cameras close at hand and their eyes trained to look out for interesting photo situations. As one true shutterbug put it, "When I wake up in the morning, I put on a camera along with my clothes."

Of course, certain subjects will never "come in over the transom." Business meetings are a prime example. I don't think we've ever gotten one from an independent photographer because no one shoots that type of subject for his or her own pleasure and independent photographers can't afford to stage business meetings themselves. So, for subjects that are in demand—like business meetings—that no one can or will shoot on his or her own, stock agencies still have to hire photographers.

In today's market, a good commercial stock photo must first be a good photograph. But not all good photos sell well in commercial stock.

For example, I recently saw a photo of the Lincoln Memorial bathed in the early morning sunlight with the statue of Lincoln dominating the center of the image. Directly underneath the statue, a sanitation worker was sweeping and, in the far left corner of the image, a pile of garbage was waiting to be dumped. It was an excellent photo—dramatic, well-composed and interesting. But the presence of the garbage and the sanitation worker gave the image too much of an editorial slant for it to be used commercially.

So, in addition to quality, the desirability of an image in stock can be determined by the following elements:

Communicability An image that will assist users in conveying their message.

Universality An image that can transcend its particular time and place in order to evoke common experiences, feelings and locales.

Simplicity An image with a single focus so that its subject can be quickly identified.

Good Use of Color An image that commands viewer attention through an expansive palette. Users like to get their "money's worth."

Versatility An image that can evoke many moods, feelings, incidents and relationships, and has applicability for a wide variety of published materials by a varied group of industries.

Drama An image that instantly captures the viewer's attention without being overwhelming or controversial.

Emotionality An image which evokes feelings or moods by subject matter, angle, color, use of light or other inherent elements, even before a headline or text is inserted.

Style An image that avoids the technically simple, clichéd and unimaginative approach to stock photography that characterized it for many years.

An Upbeat Feeling An image that shows happy, energetic people enjoying life because so many ads sell products that promise to improve or enrich the consumer's life.

Good Composition An image that encompasses not only the compositional elements common to all good photos, but also provides space to inset copy, other photos or a headline.

Timeliness An image whose subject is in particularly high demand at a given time—for example, shots of drilling rigs and pumpers during the last oil crisis, women at work during the mid-1970s, the Statue of Liberty during its 100th anniversary and health and fitness today.

Potential for Background Use An image that can serve as a somewhat neutral place on which other photos or type can be superimposed, such as shots of clouds, mountains and fields.

Originality An image that incorporates all of the elements of a good stock photo and, at the same time, manages to capture a subject uniquely or to depict a unique subject.

JAMES ONG

The Best Sellers

This book is devoted to one hundred remarkable images. Taken as a group, they've probably been selected for reproduction more often—and, in the process, earned more money—than any other one hundred commercial photographs in history.

Are they good photos? Ultimately, you, the reader, can judge that for yourself. You'll probably find some of them very appealing...and others mediocre. If you're a photographer, you may even feel that your shot of a family picnic...or tropical beach...or sunset...is better than the one included between these covers. And you may be right. Because it's not their artistic merit that makes these images remarkable.

What distinguishes these photos is their unprecedented commercial appeal. In some instances, that appeal is due largely to the choice of subject matter; in others, it stems primarily from the photographer's use of color; in still others, it's the image's versatility or composition that's responsible. The specifics may vary from photo to photo, but all of the images share one feature in common that is the most important feature of all: the ability to communicate quickly and effectively to a broad base of viewers.

Certainly, the commerciality of these images is integral to their success. But no photograph, no matter how viable, can become a best seller on its inherent strengths alone. Stock photography is not just a craft. It's also a business, and the role that a stock photo agency can play in the making of a best seller is just as important—if not more so—than any other factor.

To begin with, an agency is responsible for the marketing of an image.

Many agencies use ads, attend trade shows and apply other marketing techniques to reach their audiences, but by far the most effective means of promotion within the industry is the publication and distribution of an agency catalog. Typically, an agency catalog is a large full-color brochure with images that provide a representative cross section of its library. Sometimes a brief overview of the agency's practices and competitive advantages is included as well.

At Four By Five, however, our catalogs do more than just introduce the agency in general. Published in a series, each volume is devoted to a single subject and presents about fifty related images. Collectively, these catalogs represent a mini-stock library. In fact, many clients actually order the photos they want to use directly from these volumes. Therefore, the images in our catalogs acquire an immediacy and heightened visibility that other images don't have—an advantage which translates directly into sales.

Since we are aware of our catalogs' significant sales potential, we devote considerable thought to the selection and placement of the photos in each volume, choosing only those we think have the broadest market appeal. While being featured in a catalog won't necessarily guarantee the success of an image (we have, in fact, featured photographs which have never been sold at all), it is virtually impossible for an image to become a best seller without the visability that a catalog can offer. Most of the images in this book, for example, were included in one of our catalogs.

The second way that an agency can contribute to the creation of a best seller lies in its approach to the distribution of its photos.

Most agencies today maintain only original transparencies in their files. This restricts the use of an image to one client—and one reproduction fee—at a time.

At Four By Five, we "clone" many of the images in our library. Using today's advanced technology, reproduction-quality duplicates can be produced easily and inexpensively. In fact, some of our photos have fifty or more duplicates of each available throughout the world, making these images readily accessible and able to generate as much revenue as the international market will allow. Certainly, the best sellers in this book could never have achieved their high sales totals without this "cloning" procedure.

Who, then, is ultimately responsible for the making of a best seller—the photographers or the agency? The answer, of course, is both. Without the photographer's commercially appealing images, an agency has little of value to offer. And, without an agency's marketing and distribution skill, the photographer's images would fail to reach their earnings potential for lack of multiple exposure.

Of course, you'll want to examine these photographs for their aesthetic merit. But, bear in mind that you are viewing them as they are usually seen only in our sales catalogs or as part of a selection in the approval process—"naked," without headlines or text...or other photos inset into them...or surrounded by other photographs in a brochure or report...or within the body of an article or book. At the back of the book, you'll find samples of how some of these photos were used in several different ways by buyers and businesses for a variety of purposes.

In addition to aesthetics, try to gauge these photographs for their commercial appeal. See how many applications each one calls to your mind, what moods they suggest, what products or services you imagine they could be used to sell and what headlines they inspire. If you're like the thousands of clients who have examined and used these photos over the years, that process should keep your imagination busy for quite a while.

After all, they're *BEST SELLERS!*

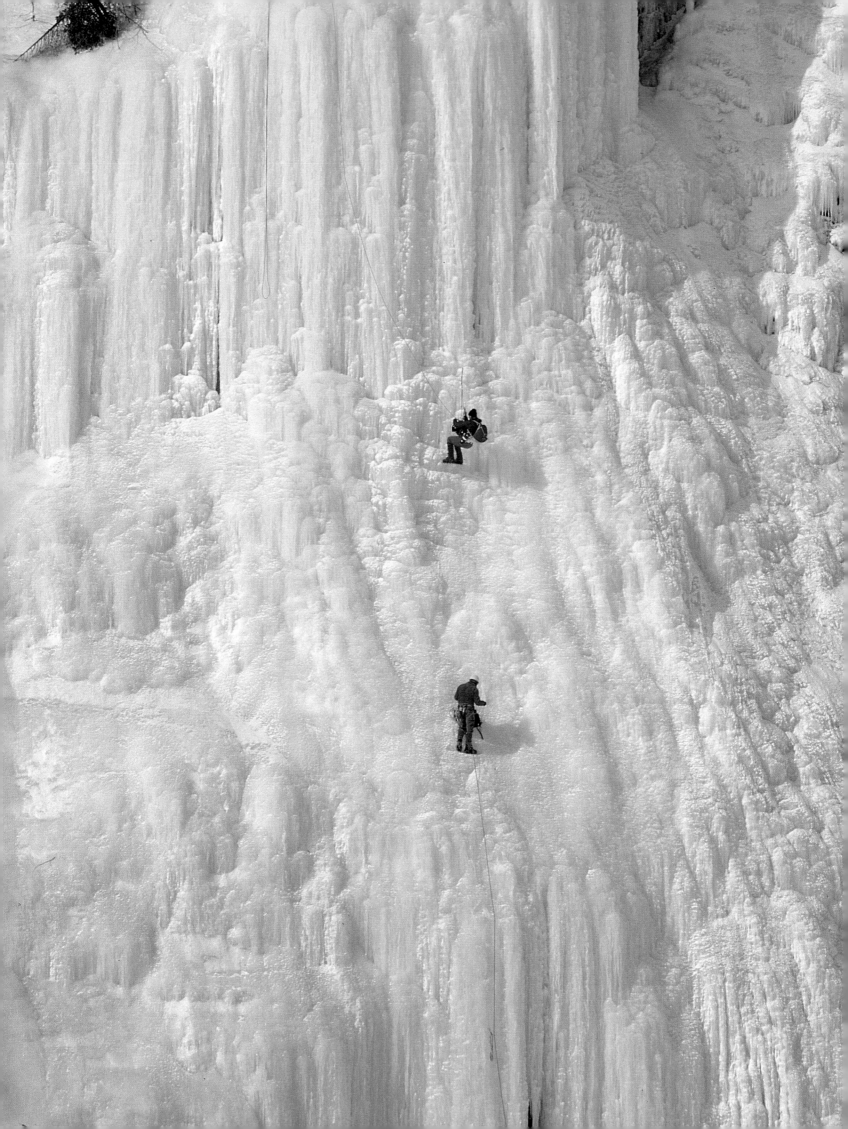

Best Seller #28
Total Sales: $22,166
Times Sold: 38
Average Annual Sales: $7,389
Average Sale Price: $583
Highest Single Sale: $1,650

Sometimes a photographer just gets lucky and comes upon a unique photo opportunity. That's what happened to the Canadian photo team Mia & Klaus who flew by these mountain climbers in a helicopter while en route to an assignment. Of course, no photographer could pass this moment by and not capture it on film. The result is simply superb. It has terrific texture. It's very colorful. The composition is wonderful, and there's even space for insets. Perhaps most importantly, it speaks volumes about everything from patience and teamwork... to challenge and achievement.

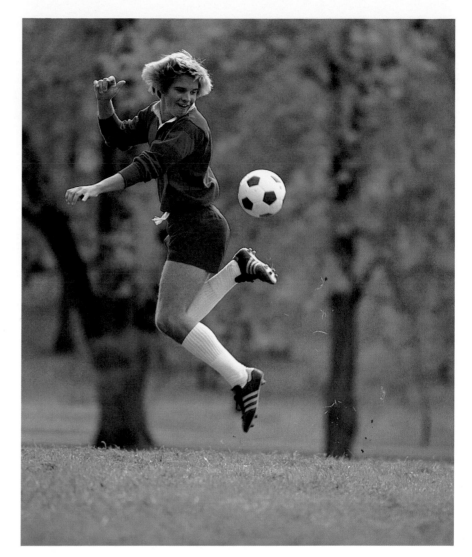

Best Seller #47
Total Sales: $16,024
Times Sold: 38
Average Annual Sales: $5,341
Average Sale Price: $422
Highest Single Sale: $1,350

The makers of autofocus cameras love this shot because the photographer has captured what Henri Cartier-Bresson called "the decisive moment." In this case, that's the point at which both ball and player are suspended in mid-air. Moreover, the player's facial expression and body language could hardly be better, the lighting is excellent and strong, appealing primary colors predominate.

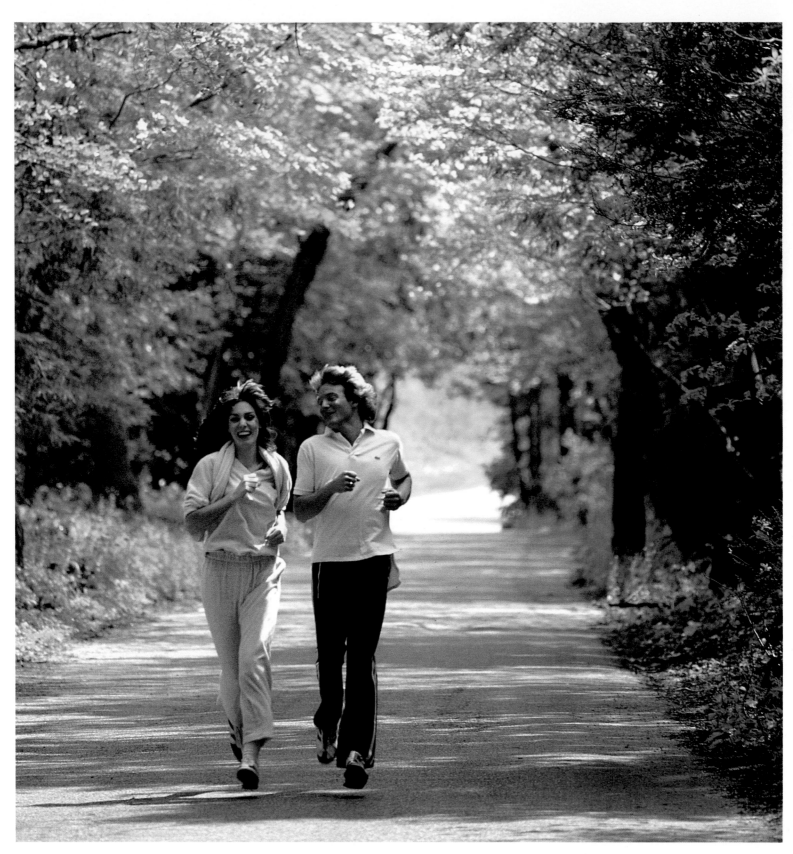

Best Seller #17
Total Sales: $25,242
Times Sold: 66
Average Annual Sales: $4,207
Average Sale Price: $382
Highest Single Sale: $950

An enterprising photographer can create his own photo sessions especially for stock. This best seller, for instance, was part of a day's shooting around the New York metropolitan area that photographer Tom Rosenthal arranged on his own. "It's not a perfect photo technically," Rosenthal admits, "but the models are fit and attractive and they are clearly enjoying each other and the vigorous, pleasurable exercise." And that, combined with a beautiful environment for jogging, makes this picture marketable to anyone selling products or services related to health, fitness or the good life.

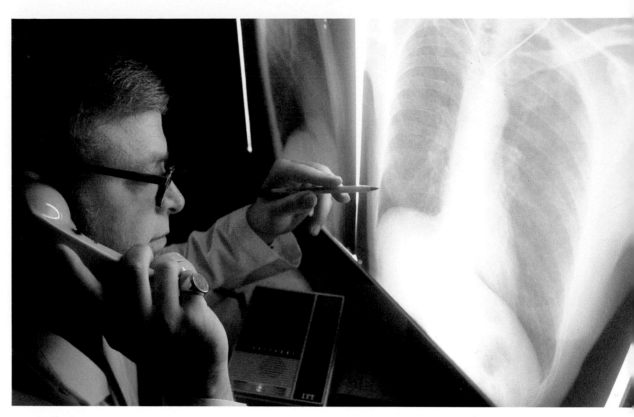

Best Seller #75
Total Sales: $11,403
Times Sold: 35
Average Annual Sales: $1,901
Average Sale Price: $326
Highest Single Sale: $750

When clients see this shot, they often ask how the photographer found himself in the situation and happened to have a camera in hand. I usually respond by saying that a good photographer is simply able to get into places that other people can't. Certainly, this photographer found an opportunistic moment for the kind of shot that is always needed for feature articles, insurance and health care promotionals and benefit plan brochures. The photographer shot it very simply, using the light from the light box to keep the primary focus on the x-ray and to throw a nice highlight across the subject's profile.

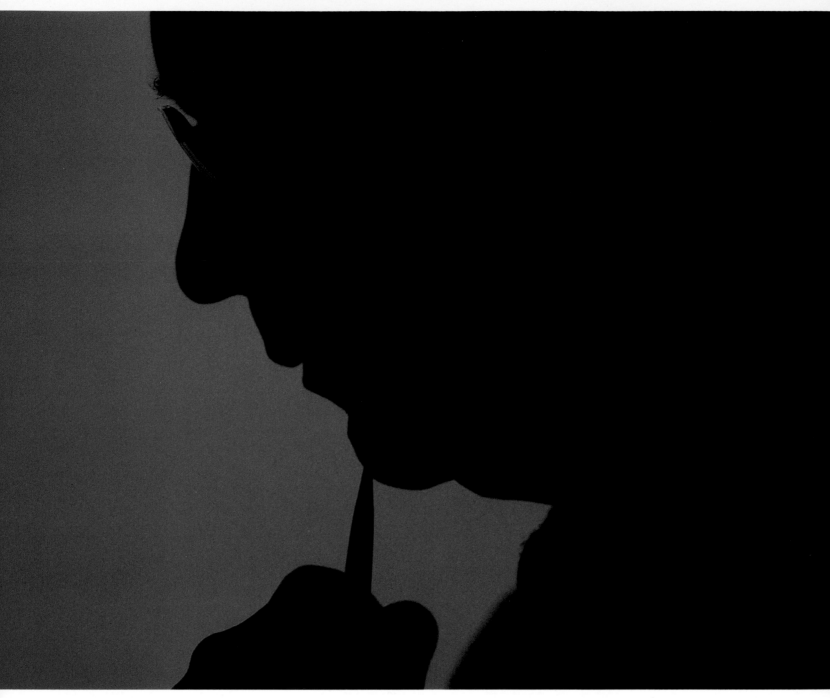

Best Seller #68
Total Sales: $11,707
Times Sold: 43
Average Annual Sales: $1,463
Average Sale Price: $272
Highest Single Sale: $750

Individuals in brokerage firms, financial service firms and other service-related companies often spend their most productive hours alone and in thought. But how can this sedentary activity be dramatically conveyed to shareholders and customers? In this best seller, Robert Llewellyn has found one solution: rely on a few carefully selected details—like the pen to the chin—to capture the cerebral moment, and, at the same time, use extreme simplicity in line and shape to command the viewer's attention.

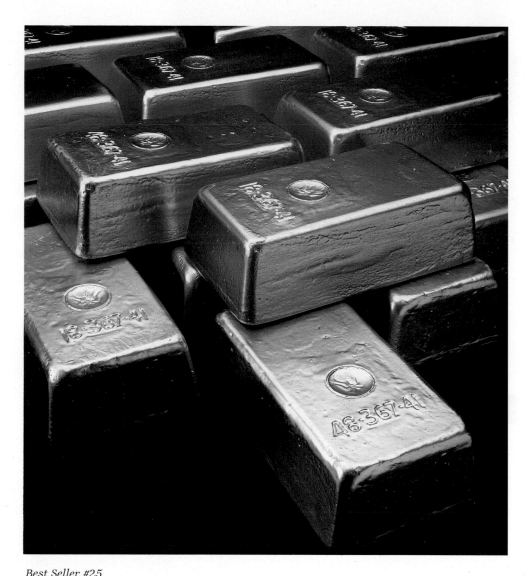

Best Seller #25
Total Sales: $22,992
Times Sold: 49
Average Annual Sales: $2,874
Average Sale Price: $469
Highest Single Sale: $5,000

I challenge you to find a better way than this to photographically suggest wealth, solvency or financial security. The subject is immediately identifiable. It has a deep rich color, which is enhanced by the black background. And it lends itself to interesting geometric patterning, as photographer Pablo Rivera effectively demonstrates. Incidentally, that's not real gold. It's clay, cast in a mold that is actually used in the making of gold bars and then spray-painted.

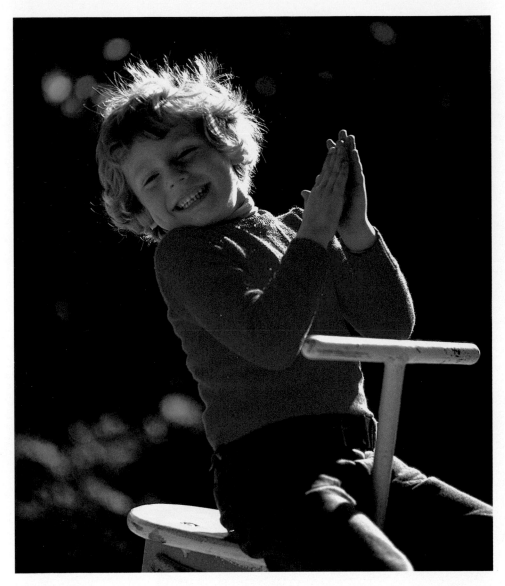

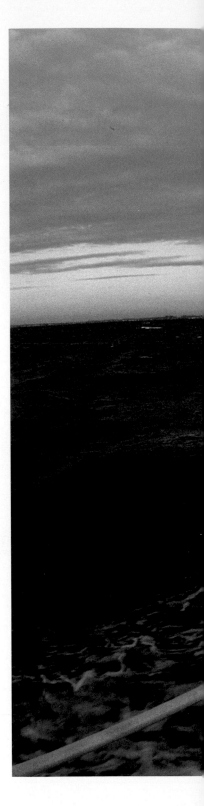

Best Seller #4
Total Sales: $56,049
Times Sold: 61
Average Annual Sales: $6,228
Average Sale Price: $919
Highest Single Sale: $20,000

"One day in Vienna, where I lived for a couple of years, I happened to come across this little boy seesawing in the park with his brother," says photographer Tom Rosenthal. "Like most Austrian kids at play, he was neatly dressed and well-groomed. Naturally, I reached for my camera. As I was shooting, something caused the boy to clap his hands in delight… I imagine it was the seesaw's sudden whoosh upward. Luckily, all the technical elements of the photo came together so that I could capture that little magic moment. For me, it was a case of being in the right place at the right time. I've tried often since then to duplicate the qualities of this photo, but I've never had the same degree of success." By the way, at $20,000, this photo has the highest single sale of any image in the Four By Five collection—and that sale was in France!

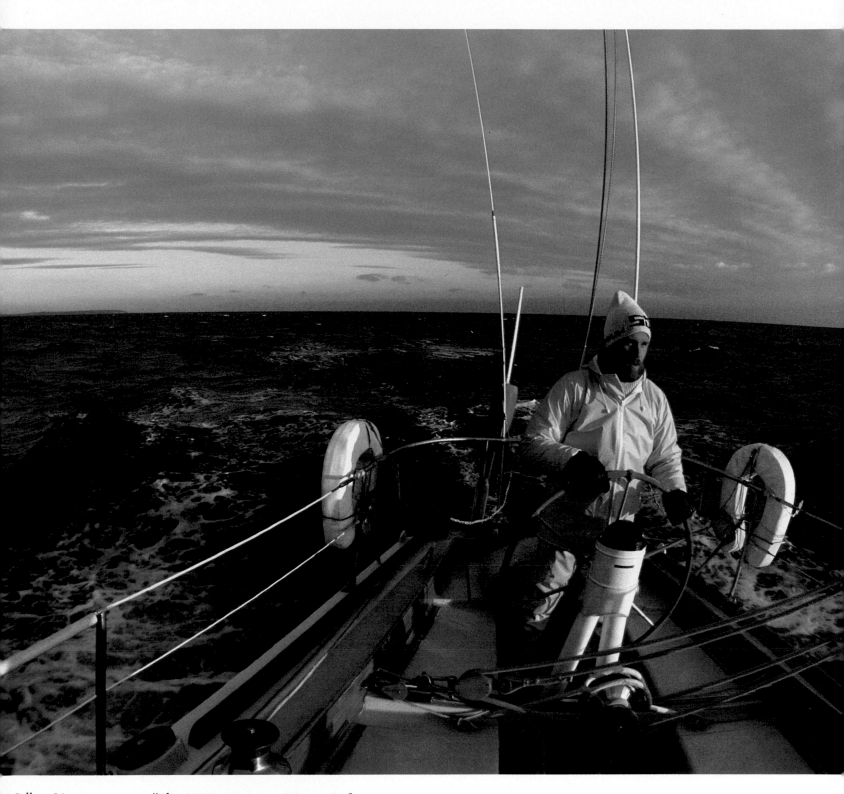

st Seller #84
tal Sales: $10,891
nes Sold: 27
erage Annual Sales: $1,815
erage Sale Price: $403
ghest Single Sale: $1,000

"About seven years ago, I was part of a six man crew hired to take a sloop from New York to Florida in January," photographer Scott Barrow told me. "It was bitterly cold, with waves cresting to 15 feet and snow or sleet an almost constant factor. The morning I took this shot was one of the few clear, relatively calm, moments on the voyage. What an adventure! It seemed like a great opportunity at the time. I didn't realize until later that I could have been killed." This fellow—"one of the few of us on the crew who really knew what he was doing," according to Barrow—has proven to be quite popular among advertisers. He could rightly take his place alongside Madison Avenue's other rugged individualists—the lean, craggy Marlboro man, the one-eyed, slightly-roguish Hathaway man and the suave, full-bearded Schweppes man.

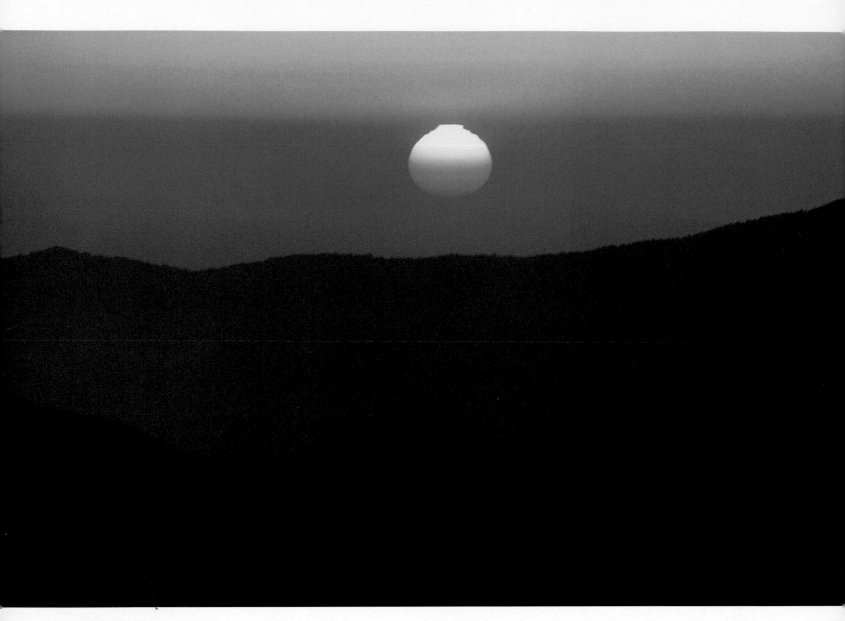

Best Seller #55
Total Sales: $14,497
Times Sold: 34
Average Annual Sales: $2,899
Average Sale Price: $426
Highest Single Sale: $750

"When I travel, I always look for photo opportunities that might have value in stock," says photographer Larry Chiger. "For example, when I was scouting locations for an assignment near Gatlinburg, Tennessee, I got up very early on several mornings, before the day's 'real work' began, and drove into the Smoky Mountains to shoot sunrises. The morning this photo was taken was particularly hot and muggy so, while I shot, I kept the air conditioning running in the car. Unfortunately, that used up all my gas and, believe me, there are no gas stations at the top of the Smoky Mountains! So I had to walk all the way down to the base, get some gas at a station and walk all the way back up again. That's what I call going out of your way to get a good picture!"

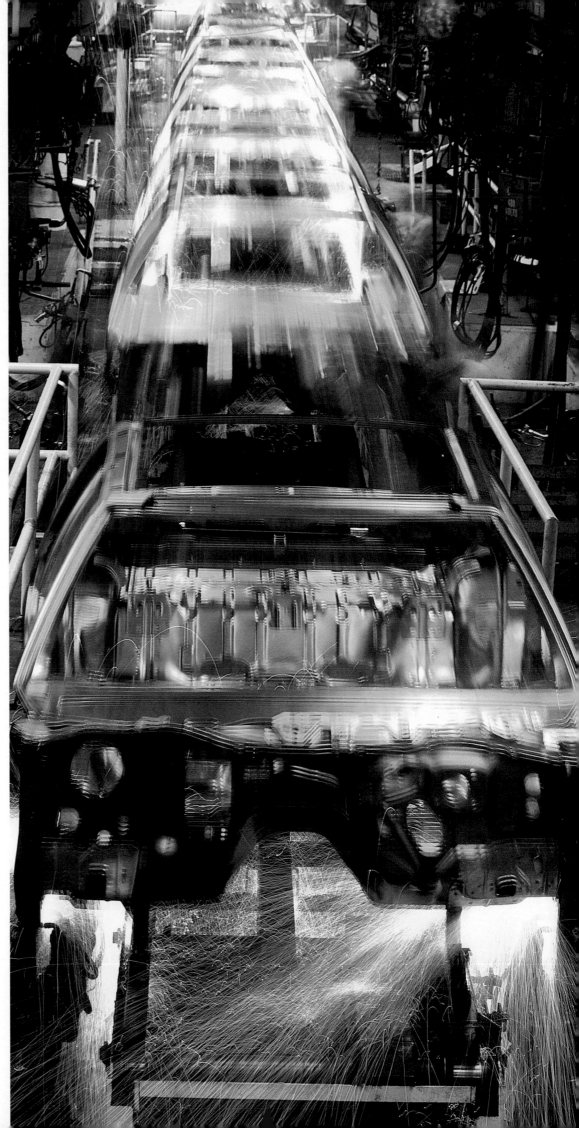

Best Seller #23
Total Sales: $23,245
Times Sold: 42
Average Annual Sales: $4,649
Average Sale Price: $553
Highest Single Sale: $1,750

In the early 1980s, we started receiving a number of requests for shots of robotics—a subject not readily available in stock. Then we read in a weekly news magazine that an automotive plant in Delaware was introducing robotics into its system. So we called the plant's public relations director, offering to provide him with photos of the facility for his files in return for allowing us to shoot inside the plant for our own library. He agreed. "Of course, we couldn't spend hours setting up," recalls photographer Larry Chiger, "so I quickly selected a gallery above the cars as my vantage point and used only available light. I set the exposure for one minute in order to blur the image, thus suggesting the motion of the cars. That—and the bright orange sparks—make the shot, I think." This image has been used not only by the automotive industry, but also in features and brochures that address the commercial uses of technology and robotics in general—proof that it pays for stock photographers and agencies to respond to the demands of the market by creating their own photo opportunities.

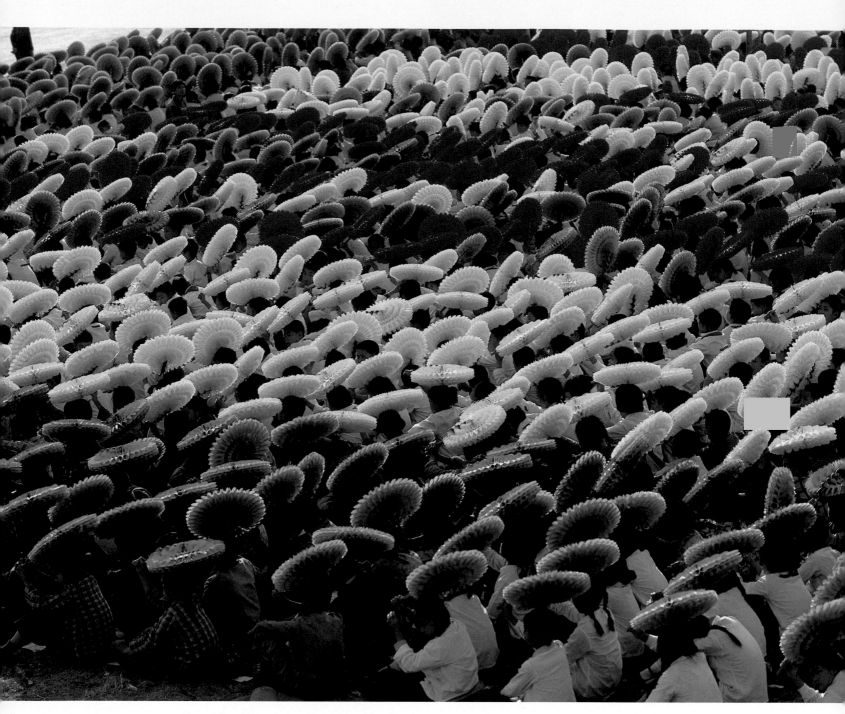

Best Seller #80
Total Sales: $11,100
Times Sold: 26
Average Annual Sales: $1,388
Average Sale Price: $427
Highest Single Sale: $800

"In 1979, I went to China on one of the first tours for private citizens since the Revolution," recalls photographer Steve Vidler. "It was incredible. Everywhere we went, people followed us. They were honest, friendly, curious. They'd never seen us 'foreign devils' before. But it was a pretty colorless country, with people in Mao suits everywhere. So, naturally, when I saw a busload of kids in Nanning with brightly colored fans, my interest was peaked. I followed the bus to a field where the kids were arranged on the ground and were rehearsing for a rally—using the fans to create messages just like stadium cards are used here at football games. I'm delighted that this photo is so popular. Of course, my shot of the Great Wall was the biggest seller from that trip—it still sells well today—but this one appeals to those who want to show the spirit of China without resorting to that quintessential image."

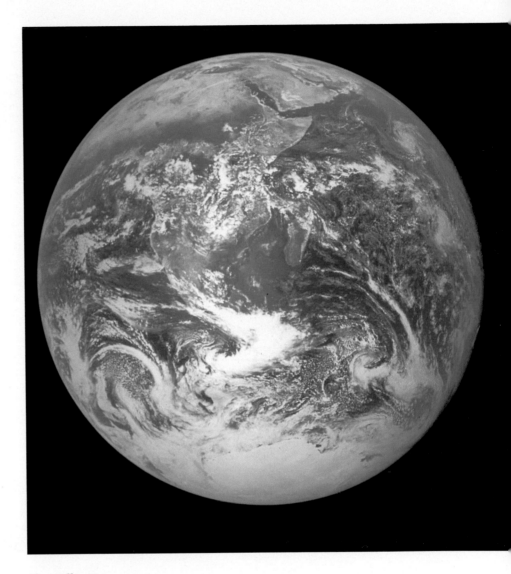

Best Seller #9
Total Sales: $32,537
Times Sold: 134
Average Annual Sales: $3,254
Average Sale Price: $243
Highest Single Sale: $1,500

With this image of the earth—taken during the moon landing of Apollo 17—it became possible, for the first time, to replace illustrations and other imaginative images of our world with a photo of the real thing. That's a very desirable commodity, not only for texts on science and astronomy, but also for corporations offering a global outlook or a world-wide presence—which is why this is probably the most widely used photograph in the world. Like all of NASA's images, this one is in the public domain, and can be used by anyone anywhere in the world... compliments of the U.S. taxpayer!

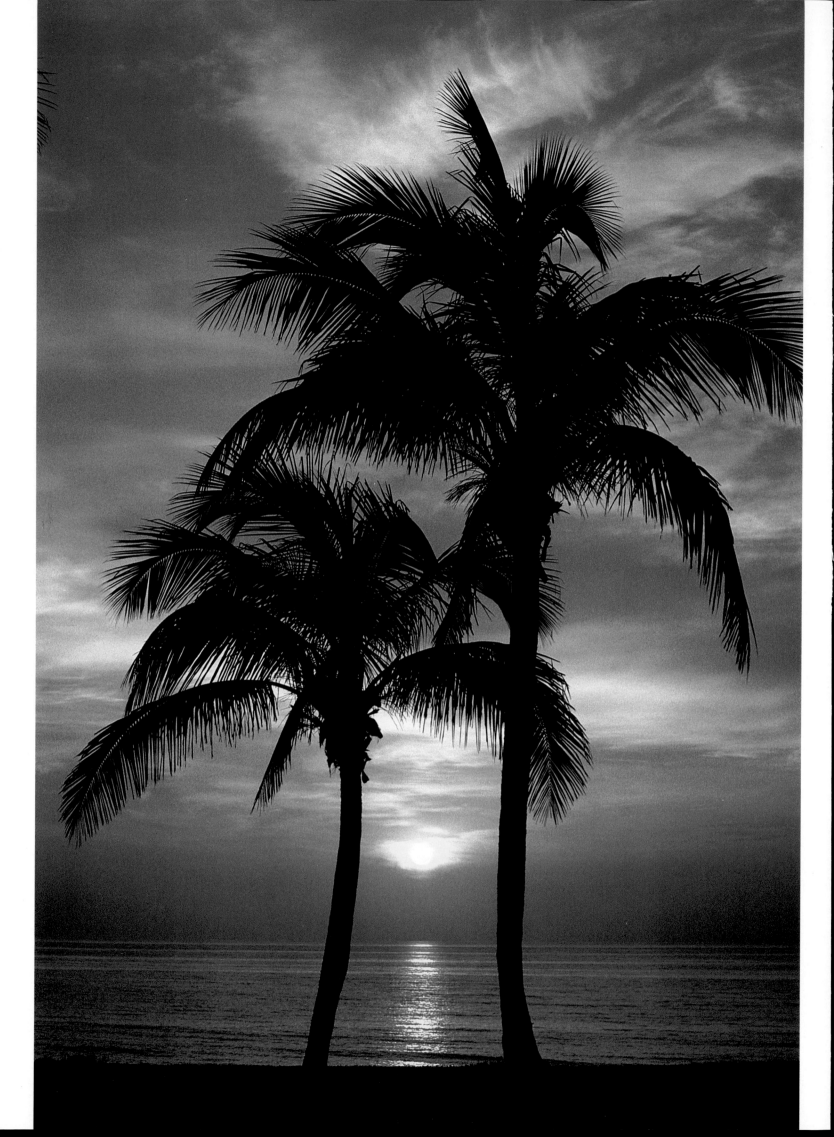

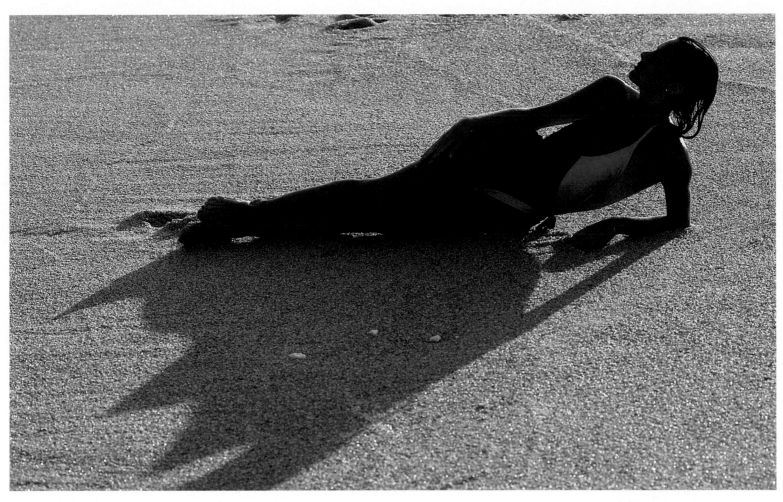

Best Seller #30
Total Sales: $21,063
Times Sold: 57
Average Annual Sales: $4,213
Average Sale Price: $370
Highest Single Sale: $900

When time is a major factor—as it often is in advertising and corporate communications—finding a good picture quickly may be more important than slowly perusing every available image in order to find the very best one. For stock photo agencies who know this, careful consideration is given to the selection and display of images in company catalogs. This photograph, for example, was prominently featured in a catalog where it was seen by many individuals in need of a generic tropical landscape. By simply calling and ordering it, they were able to avoid the potentially lengthy search and selection process. Furthermore, they were able to obtain one of the best photos on the subject—one often chosen after a review process—which is why it was in the catalog in the first place.

Best Seller #52
Total Sales: $15,045
Times Sold: 21
Average Annual Sales: $2,507
Average Sale Price: $716
Highest Single Sale: $2,000

"I took this shot when I was a photographer's assistant," recalls Larry Chiger. "We were in Cabo San Lucas, Mexico doing a layout for a fashion magazine and, at the end of the day, one of the models agreed to pose while I took some shots for stock. Because of the time of day, the sun was casting very large shadows on the sand, and I decided to position the model to take avantage of that. What emerged, as you can see, is an interesting study, with the round contours of the model's body contrasted by the sharp angles of her shadow." This contrast, the texture of the sand and the photographer's inate good taste give this best seller a strong graphic quality that is largely responsible for its commercial success.

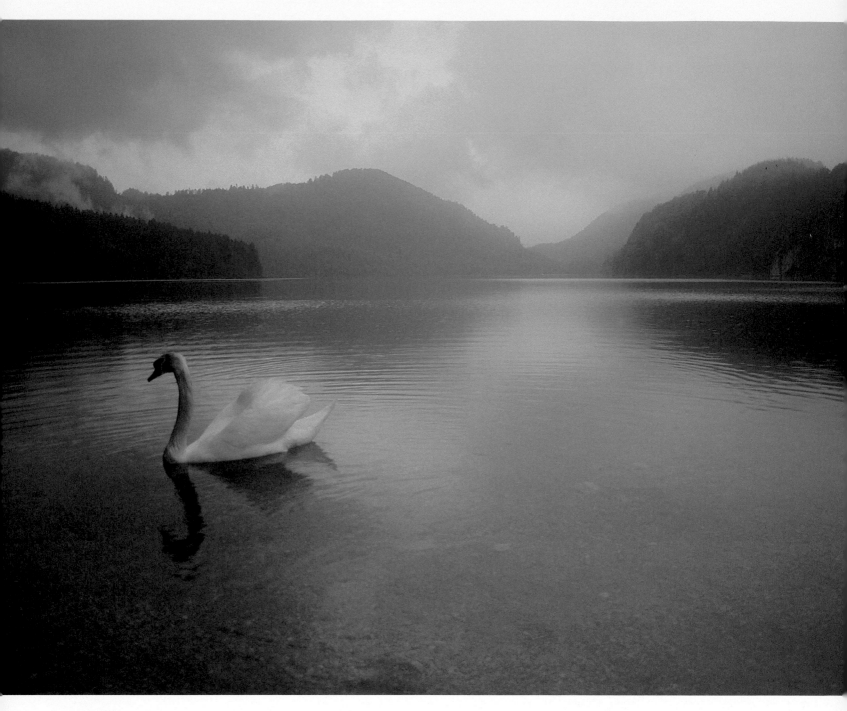

Best Seller #26
Total Sales: $22,611
Times Sold: 59
Average Annual Sales: $2,826
Average Sale Price: $383
Highest Single Sale: $1,400

Take a gray day, a small lake and a lone swan; add a blue filter to enhance the monochromatic quality of the image, and the result is a beautiful composition that has graced not only the cover of a greeting card and an inspirational book, but has also appeared in promotional materials for products that stress purity and softness. These products have included textiles, carpets and mattresses. The photo also has an air of loneliness, singularity and just plain "blue mood" about it.

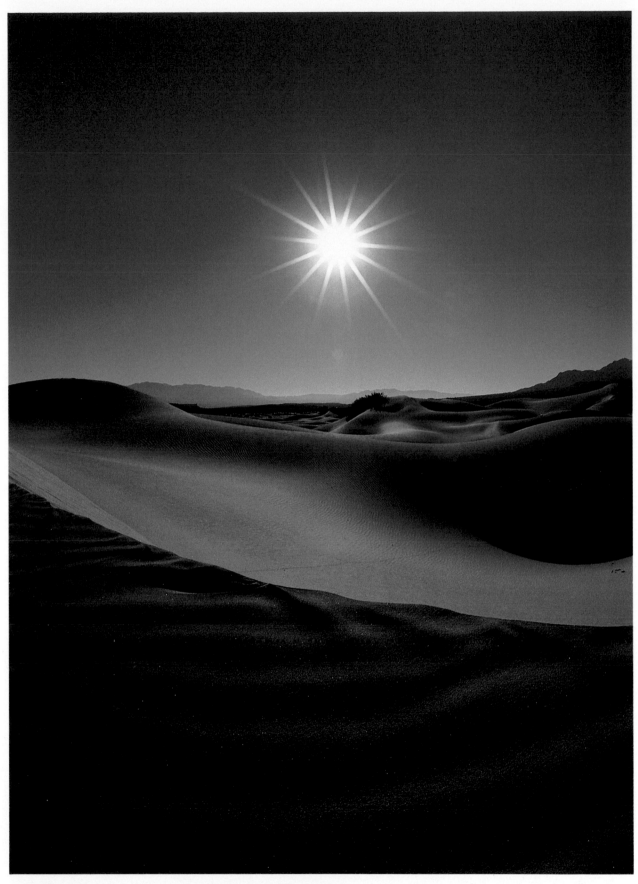

Best Seller #10
Total Sales: $29,953
Times Sold: 80
Average Annual Sales: $3,744
Average Sale Price: $374
Highest Single Sale: $1,250

This is an almost perfect sunflare. That's a very rare occurence, and one which is possible only when the atmosphere is extremely clear. The mystical quality of this sky—enhanced by the pink halo around the sun—has been used by a popular magazine to illustrate an article entitled "Into the Unknown", while the soft undulations of sand have served the needs of a Las Vegas hotel, a tire manufacturer and several carpet companies.

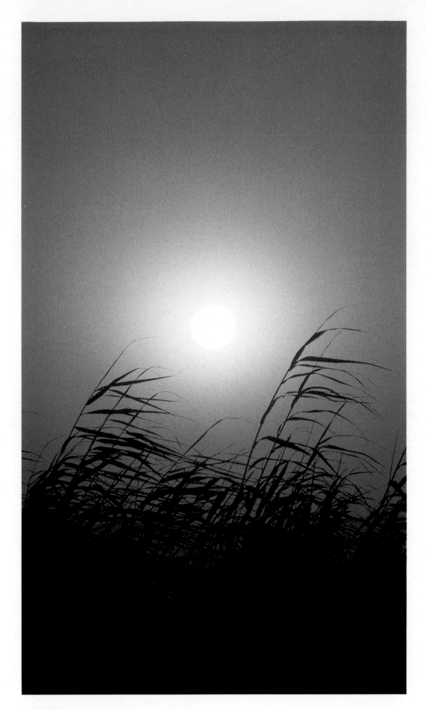

Best Seller #34
Total Sales: $19,958
Times Sold: 81
Average Annual Sales: $1,996
Average Sale Price: $246
Highest Single Sale: $1,000

Graphic designers today are increasingly using photographs as neutral planes on which they can inset other photographs, headlines or copy. From Florida to California, from Indiana to Arizona—this photo has been featured as a background many times—for a hotel menu; a country club invitation; the packages of a dairy creamer, a vitamin supplement and a rice company; point-of-purchase materials for a fast-food burger chain; an auto dealership brochure; the cover of a health care journal; a religious book jacket; a record album; and a high school yearbook!

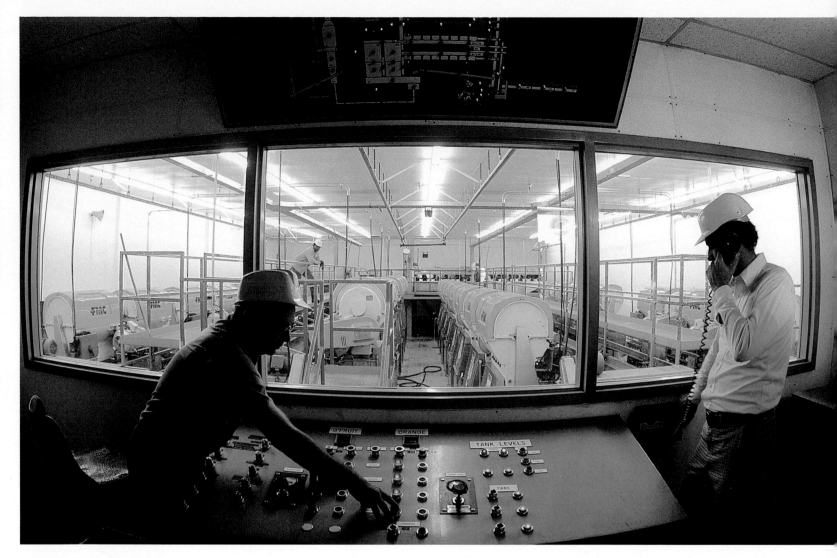

Best Seller #50
Total Sales: $15,298
Times Sold: 39
Average Annual Sales: $2,550
Average Sale Price: $392
Highest Single Sale: $1,500

"This is the control room of a fully automated citrus processing plant in Florida," photographer Robert Llewellyn told me. "I shot it while on assignment for the Department of Agriculture. The control room was very tiny, so I couldn't stand back and use a wide-angle lens. Therefore, to capture as much of the space as I could (an important consideration when shooting documentary photos for the government) and to show the processing area beyond, I used a 'fisheye.'" The result is a powerful statement about industrial control and state-of-the-art technology—one that has been used over and over again by those in the engineering and digital electronics industries and by those who cover such industries in the press.

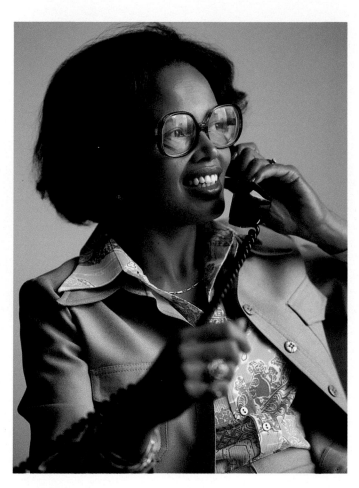

Best Seller #45
Total Sales: $16,131
Times Sold: 62
Average Annual Sales: $2,016
Average Sale Price: $260
Highest Single Sale: $600

Take a black woman who is attractive but doesn't look like a model, clothe her in a colorful suit and blouse, show her in the most natural and common of business situations—talking on the telephone—and you have an image that is in high demand and short supply among equal opportunity employers and advertisers targeting black middle-class consumers.

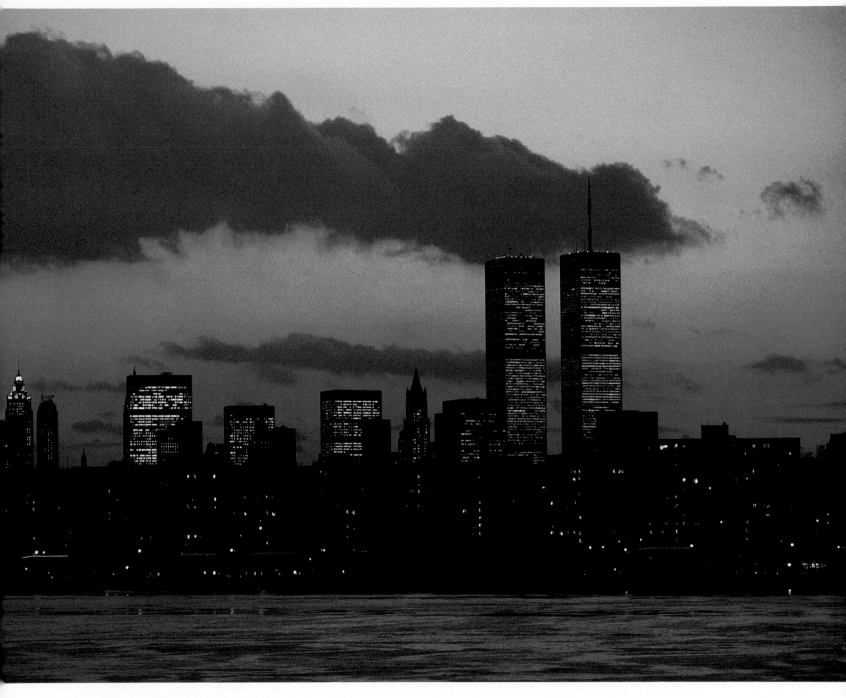

Best Seller #19
Total Sales: $24,427
Times Sold: 36
Average Annual Sales: $6,107
Average Sale Price: $679
Highest Single Sale: $2,750

All the power, majesty and mystery of "The Big Apple" are captured in this skyline. But of all the City's many aspects, this photographer's image most vividly calls to mind the romantic New York of song and story—the New York that only lovers know. Anyway, that's what Hollywood saw in this picture when it was selected as the central image to promote the hit movie *Splash*.

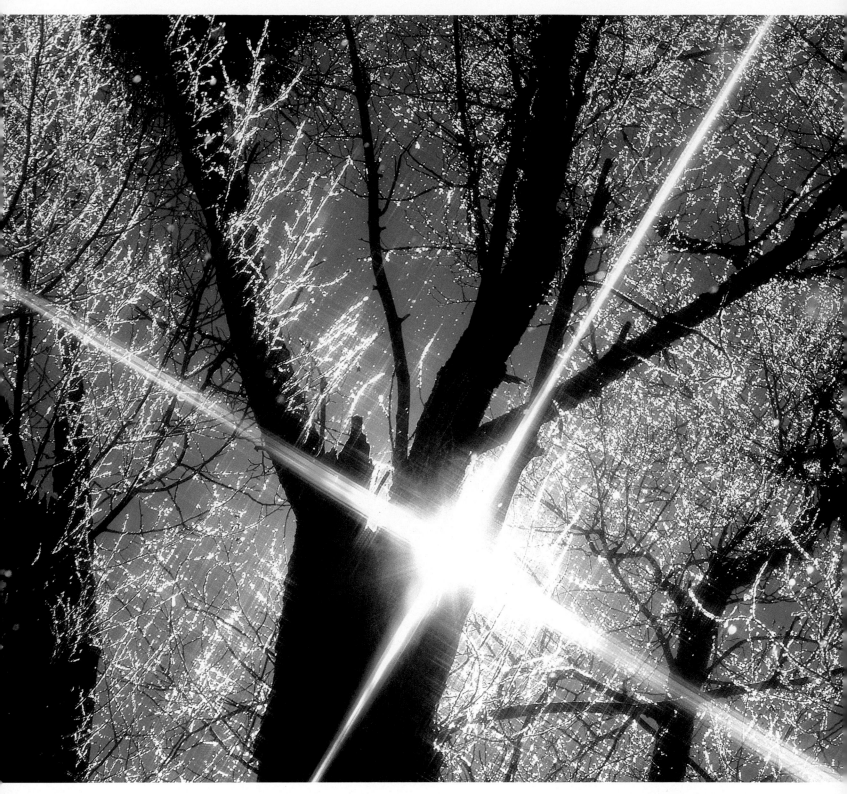

Best Seller #85
Total Sales: $10,850
Times Sold: 21
Average Annual Sales: $3,617
Average Sale Price: $517
Highest Single Sale: $1,750

Photographer Ron Dahlquist lives in Steamboat Springs, a beautiful resort area in northern Colorado. He spends about eight months of each year trying to capture the beauty of the area's natural surroundings and its cool climactic clarity. A case in point is this shot of monolithic pines with frost glinting on their branches set against an intense blue sky. To get the flare in the center, he shot directly into the sun using a four point star filter.

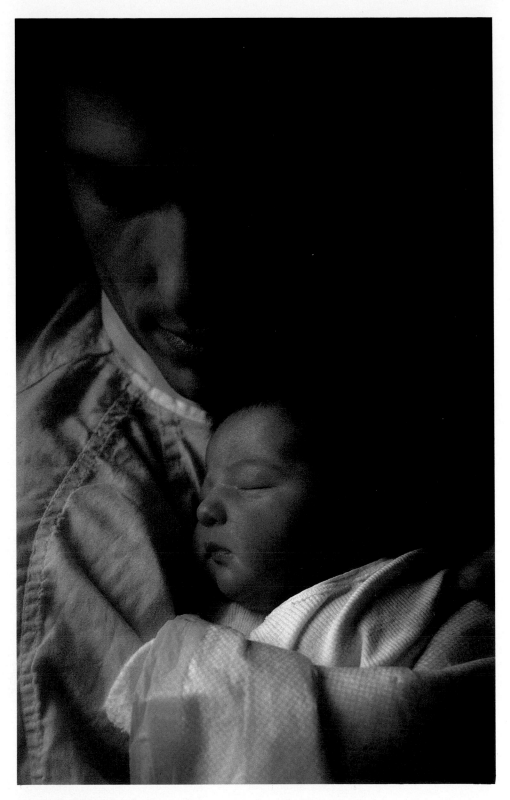

Best Seller #48
Total Sales: $15,855
Times Sold: 39
Average Annual Sales: $1,982
Average Sale Price: $407
Highest Single Sale: $2,500

"I took this shot in the hospital about an hour after giving birth," says the baby's mother, Carla Moore. An amateur photographer, she accidentally underexposed the image, which effectively eliminated all of the extraneous hospital room details from the background and cast very dramatic shadows across the faces of her husband and son. With the increasing number of women in the work force today and the attendant rise in shared child care between parents, the demand for shots like this one is on the rise.

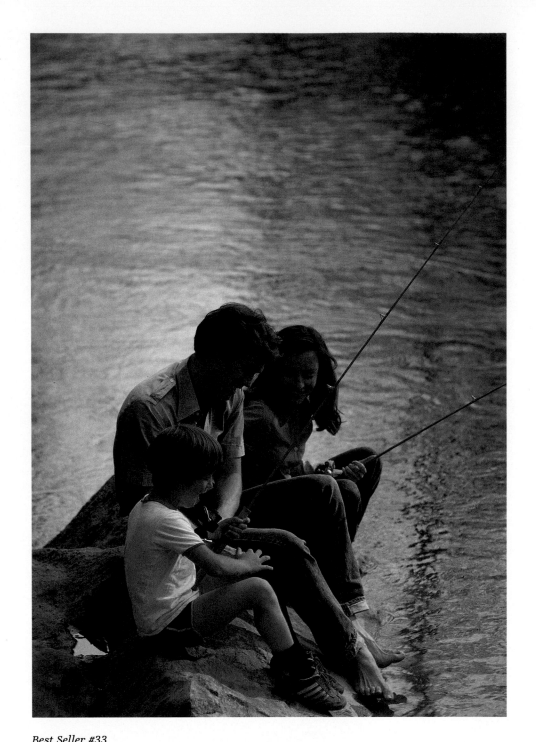

Best Seller #33
Total Sales: $20,017
Times Sold: 69
Average Annual Sales: $2,860
Average Sale Price: $290
Highest Single Sale: $625

Insurance, banking and health products and services are just a few of the industries whose activities are directed toward the enhancement and preservation of family life and the protection of a family's future. For these companies, this photo is perfect. The models are attractive... but they don't look like models. The colors are strong and vibrant and the composition simple, depicting a popular recreational activity. And the background is minimized to keep the focus of attention where it should be—on the people.

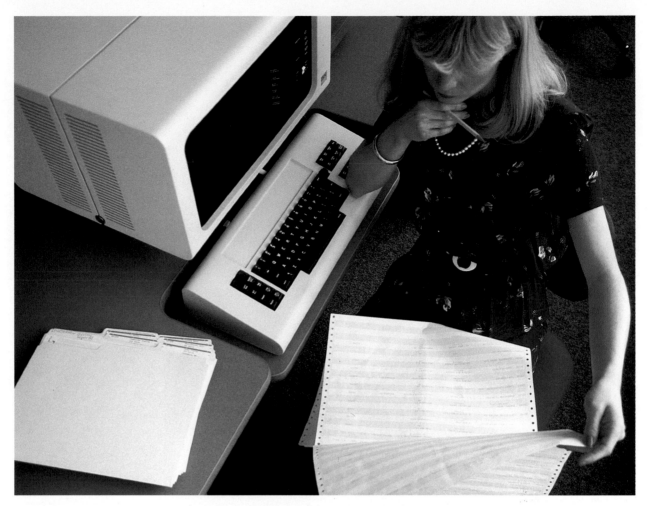

Best Seller #49
Total Sales: $15,571
Times Sold: 49
Average Annual Sales: $5,190
Average Sale Price: $318
Highest Single Sale: $550

This best seller effectively combines the two most significant trends in today's business environment—the rising use of technology and the rapid influx of women in the work force. By shooting down from above, photographer George Glod has given potential users an alternative to the eye level approach that typifies most images of desktop work.

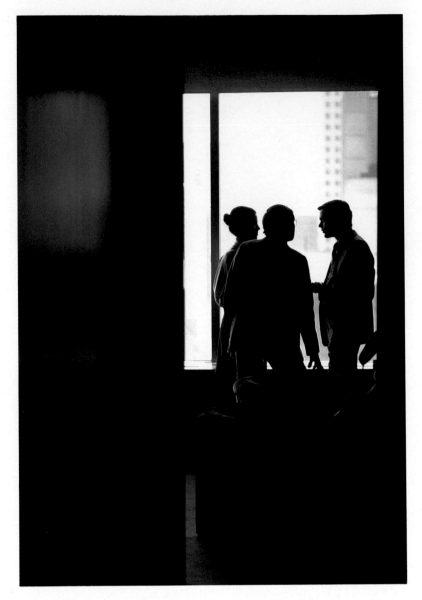

Best Seller #1
Total Sales: $75,131
Times Sold: 156
Average Annual Sales: $12,429
Average Sale Price: $481
Highest Single Sale: $2,500

"I was en route to Jamaica for the first time when I looked out of my window at about 30 thousand feet and became entranced by this beautiful sight," says photographer Tom Rosenthal. "Naturally, I reached for my camera, but, having never attempted aerial photography at such an altitude before, I used several different lenses, a couple of filters and two rolls of film. I just hoped something would work out right—and I guess it did!" As a matter of fact, this image has generated more cumulative revenue—$75,131—than any other photo in the library at Four By Five.

Best Seller #6
Total Sales: $44,145
Times Sold: 141
Average Annual Sales: $6,306
Average Sale Price: $313
Highest Single Sale: $900

Within its minimalistic use of light, color and space, this photograph incorporates a remarkable amount of significant information. It's obviously set in a modern high-rise office building with well-appointed decor and furnishings. The individuals could be co-workers, or they could represent company executives and clients. A woman is featured along with men—an important consideration for most equal opportunity-conscious companies today. This is a seven-year-old photo, but despite changing fashions and hair styles in the intervening years, it's as effective today as it was on the day it was shot.

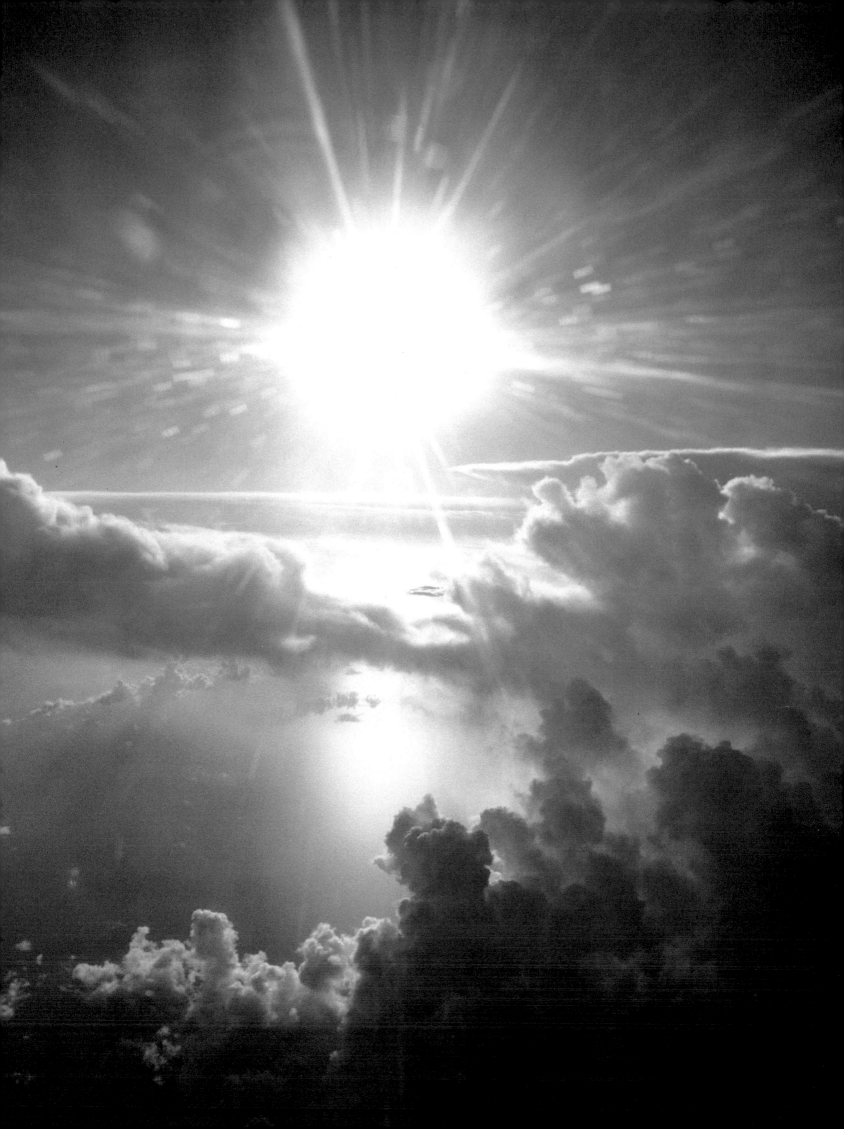

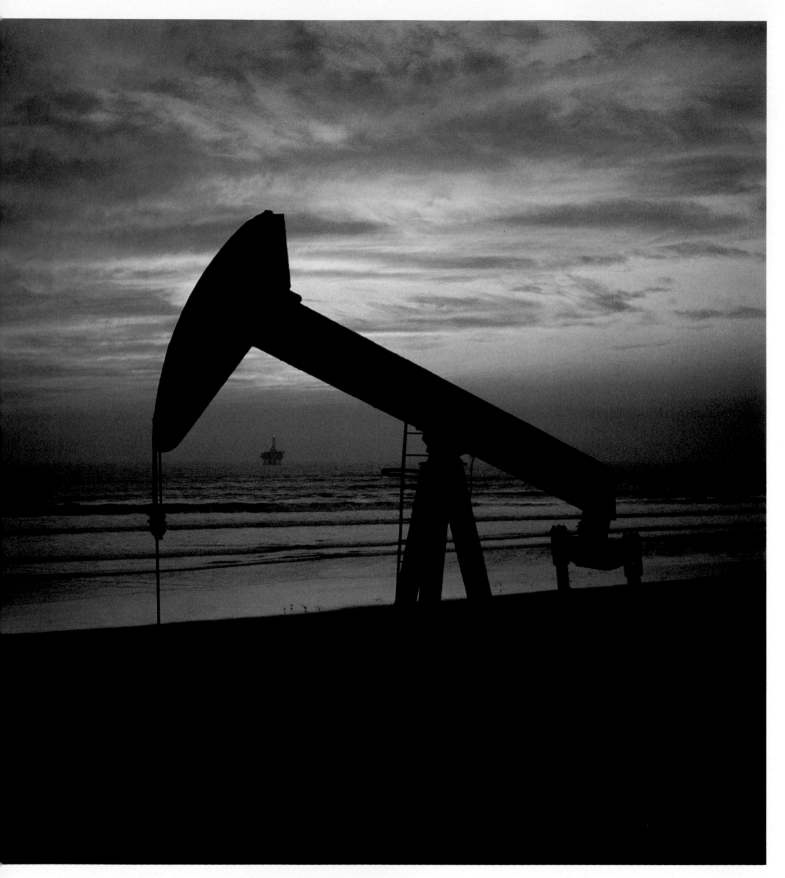

Best Seller #37
Total Sales: $18,725
Times Sold: 41
Average Annual Sales: $3,121
Average Sale Price: $457
Highest Single Sale: $2,000

"I've taken hundreds of shots of oil pumpers over the last ten years," says photographer Mick Roessler. "I live about two miles from Huntington Beach where there are a lot of them. So, when I see an interesting weather pattern developing, I have the time to grab my camera and get down to the beach before conditions change. It was a very beautiful evening the night this photo was taken." In addition to the sunset, what distinguishes this shot is the small offshore drilling station just visible within the angle of the "horse head" pumper.

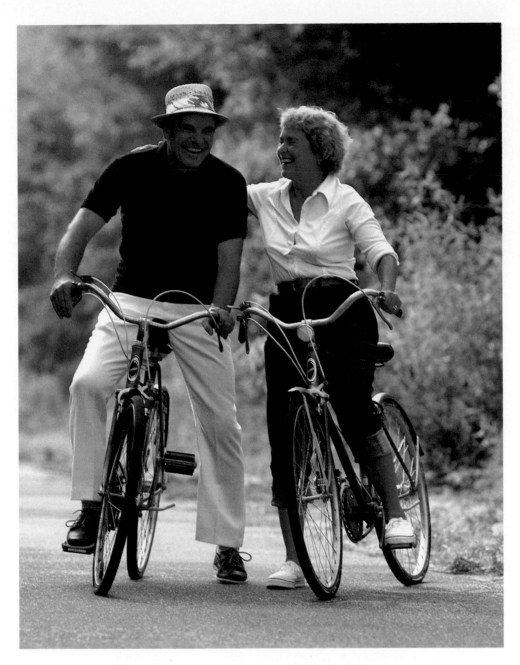

Best Seller #5
Total Sales: $48,042
Times Sold: 151
Average Annual Sales: $8,007
Average Sale Price: $318
Highest Single Sale: $1,250

Companies that provide health care, insurance, retirement housing and banking frequently need good photos of healthy, "older" couples. But shots like that are somewhat difficult to find in stock. To fill this void, we engaged a photographer, found an attractive location in South Carolina and brought our parents and friends along as models. From the day's shooting—which involved several different situations—this image emerged as the biggest seller.

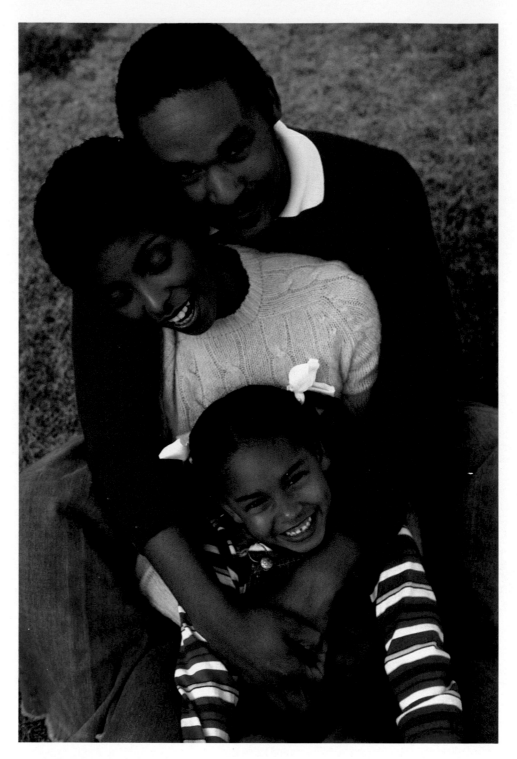

Best Seller #24
Total Sales: $23,076
Times Sold: 74
Average Annual Sales: $3,846
Average Sale Price: $312
Highest Single Sale: $1,500

In the early 1970s, advertisers had a very difficult time finding good stock photos of minorities. To meet the constant demand, we finally commissioned this shot in 1980. In the six years since that time, it has been used on an average of *once a month* to sell a wide variety of goods and services. Except for the United States, no other country in the world has a large, autonomous black consumer group. If they did, this photo would surely be an even bigger best seller.

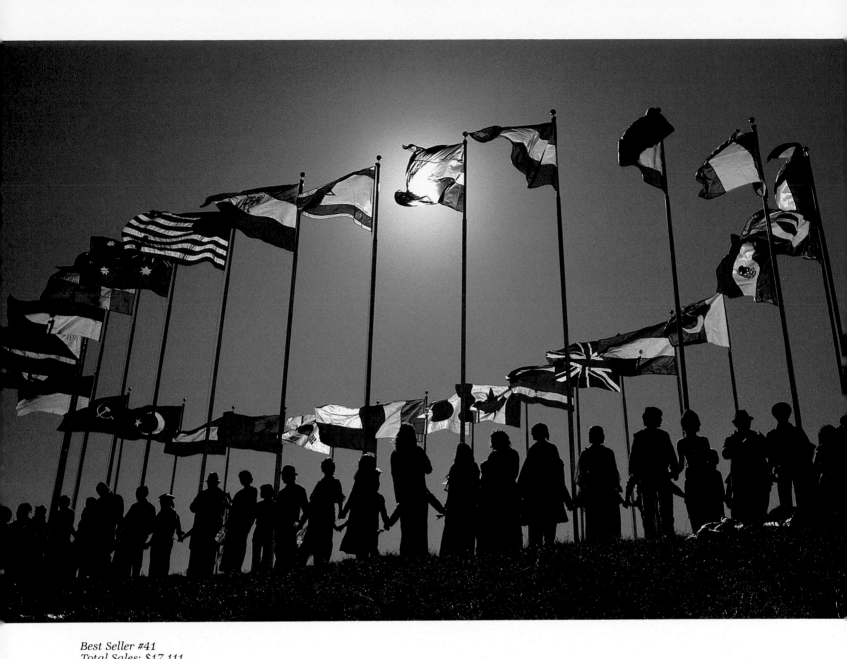

Best Seller #41
Total Sales: $17,111
Times Sold: 57
Average Annual Sales: $1,711
Average Sale Price: $300
Highest Single Sale: $1,000

"No, this is not the United Nations or even an international brotherhood camp," laughs photographer Bo Richards. "It's a chewing gum commercial! I was simply driving by Mount Tamalpais in Marin County (California) where it was being filmed, saw a hillside full of people and flags from all over the world, and asked permission to shoot a couple of stills." The result, a truly unique stock image, has been used to make statements about global harmony, friendship and peace.

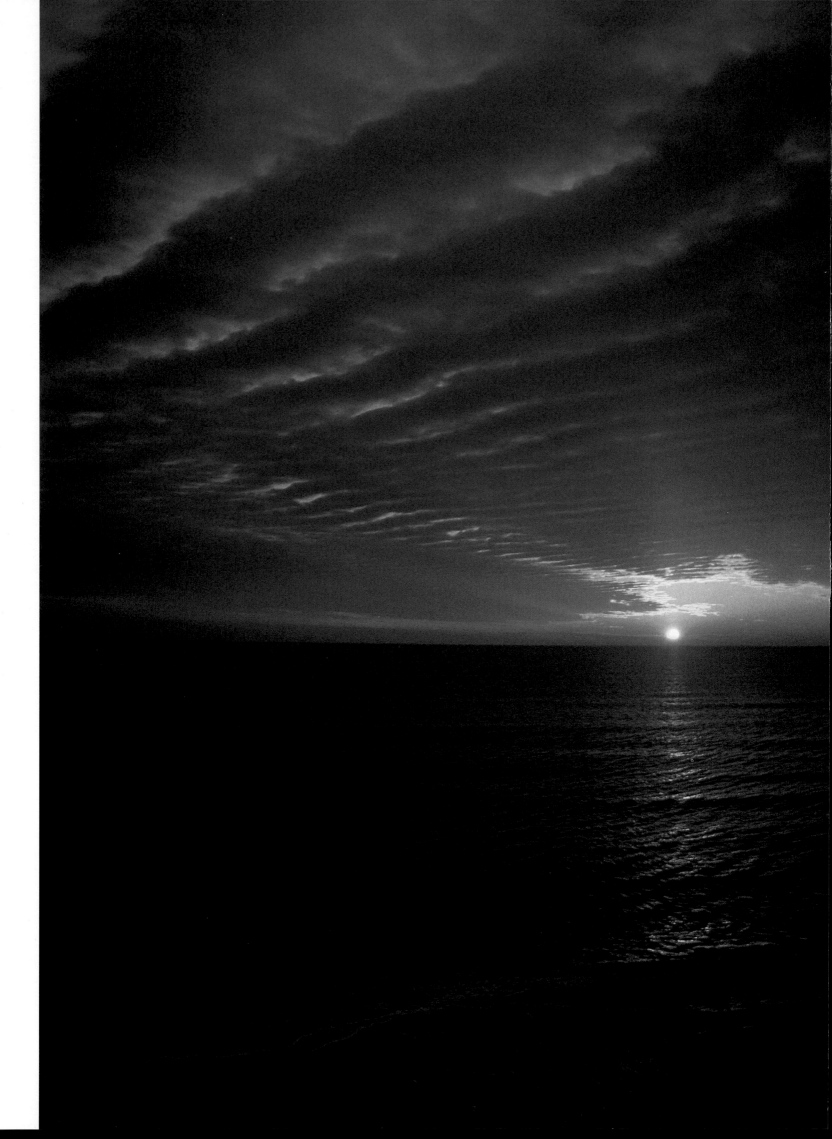

Best Seller #3
Total Sales: $63,301
Times Sold: 148
Average Annual Sales: $7,913
Average Sale Price: $428
Highest Single Sale: $3,850

"I'm much more interested in capturing the emotional content of a situation than I am in documenting what occurred," photographer Robert Llewellyn told me. "For example, when I'm captivated by a scenic vista—as I was with this February sunrise in Virginia Beach—I'll use a wide-angle lens. Other times—when I find a particular aspect of a situation more compelling than its whole—I'll use a long lens to isolate that detail. Either way—through close-ups or long-shots—I try to convey what it *felt* like to be where I was when I created the image and, in so doing, to engage the viewer, not as a passive spectator, but as an active participant in whatever experience the picture conveys."

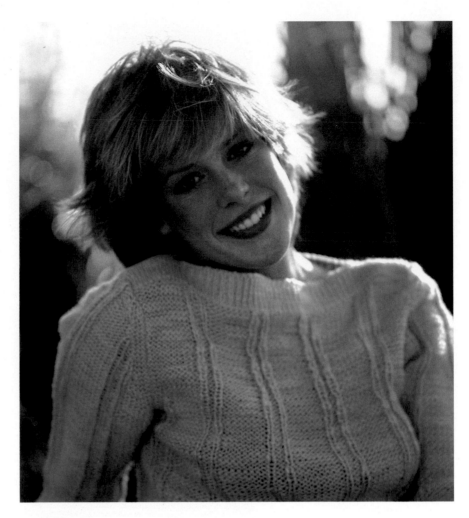

Best Seller #83
Total Sales: $10,910
Times Sold: 17
Average Annual Sales: $2,182
Average Sale Price: $642
Highest Single Sale: $3,000

In this best seller, photographer George Glod has given us a "candid" portrait of the typical all-American girl. Fresh, open and full of life—she can represent the target audience of a wide variety of products and services—from toothpaste to camera equipment to insurance policies. In fact, when this photo appeared on the cover of a national magazine, the model's image was so appealing that she was invited to make a screen test by a major movie studio!

Best Seller #36
Total Sales: $19,138
Times Sold: 64
Average Annual Sales: $2,392
Average Sale Price: $299
Highest Single Sale: $1,000

Photographer Robert Llewellyn has provided an unusual and intriguing composition for companies who want to stress their worldwide presence or global outlook. The intense colors, animated silhouettes and skyscrapers in the background give this image particularly strong appeal for use in the annual reports of multinational companies. Moments before shooting this scene, Llewellyn shot best seller #6 using some of the same models. *Two* best sellers?? Not bad for a few hours work!

Best Seller #97
Total Sales: $9,525
Times Sold: 14
Average Annual Sales: $3,175
Average Sale Price: $680
Highest Single Sale: $1,500

In today's fast-paced, highly competitive business environment, women are equal to men in sacrificing the niceties of life—like lunch—for the exigencies of the job. In his evocation of the modern work ethic, Pablo Rivera has chosen a predominantly black-and-white palette with a few brilliant flashes of color in the sandwich, the cup and the model's flesh tones, hair and lipstick. A subtle sense of urgency is added to the composition by positioning the model on an angle. This is highlighted by the vertical accents in her blouse and balanced by the horizontal planes of the venetian blind behind her.

Best Seller #66
Total Sales: $12,656
Times Sold: 22
Average Annual Sales: $1,582
Average Sale Price: $575
Highest Single Sale: $600

In 1931, the great photographer Lewis Hine documented the construction of the Empire State Building, likening those who built it to Icarus, the hero of Greek mythology who soared in the sky. Today, Scott Barrow captures the achievements of the modern-day construction worker in a style reminiscent of his famous predecessor, but with the addition of color. His memorable images of the individuals who brave the elements and seemingly defy gravity to erect today's towering edifices have served well the needs of those who build, finance, invest in, lease and sell our modern high-rises.

Best Seller #18
Total Sales: $24,500
Times Sold: 69
Average Annual Sales: $3,500
Average Sale Price: $355
Highest Single Sale: $1,625

In the early days of stock photography, images like this one tended to have a clichéd, greeting card quality about them. Today, we've become much more adept at creating photos that are generic without being trite. This photo, for example, took a great deal of time and skill to produce—from casting the right-looking quartet to finding an environment that would enable us to surround our subjects with lush green foliage and, at the same time, not block out the natural light. But the result looks unposed and completely natural—like a snapshot. To the untrained eye, the skill and manipulation of the photographer are not at all apparent.

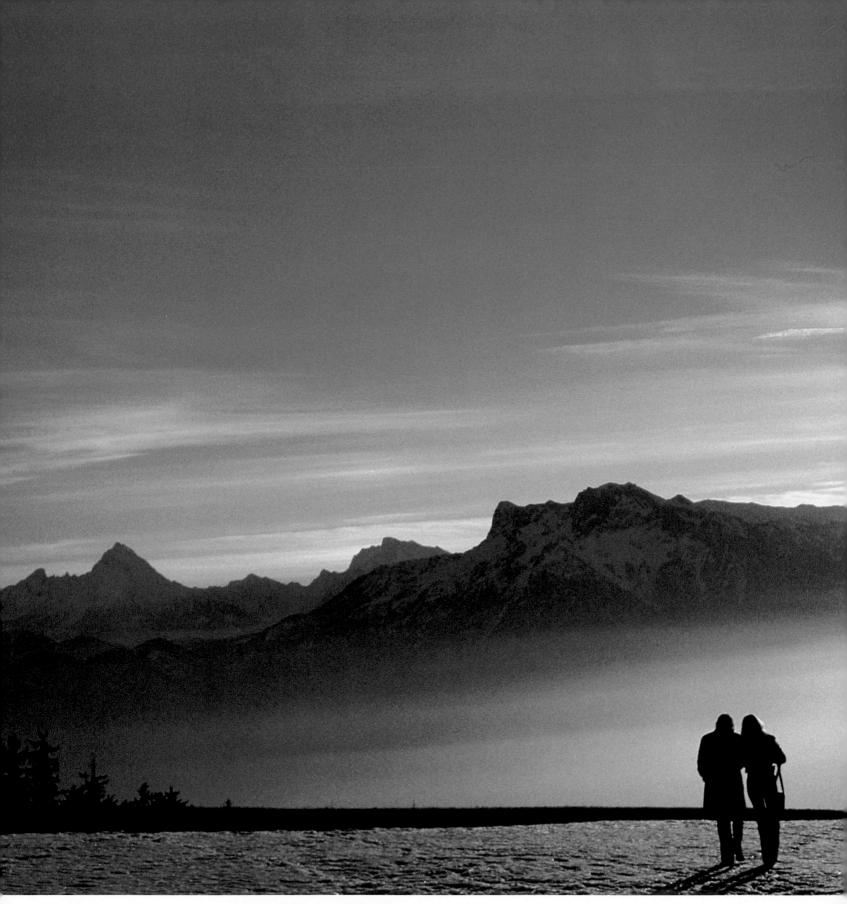

Best Seller #71
Total Sales: $11,533
Times Sold: 45
Average Annual Sales: $1,048
Average Sale Price: $256
Highest Single Sale: $850

Photographer Tom Rosenthal tells me that people from everywhere come to this famed vista near Salzburg, Austria to drink beer at the Almshütte and watch the sun set. "Unlike most mountain peaks which require a long hike or a cable car," he says, "this one is just a short drive up a mountain road from the city. Of course, once you get there, you only have about four minutes when the setting sun is just right for shooting." Looking at this photo now, many years later, he sighs fondly and says, "What a magical place."

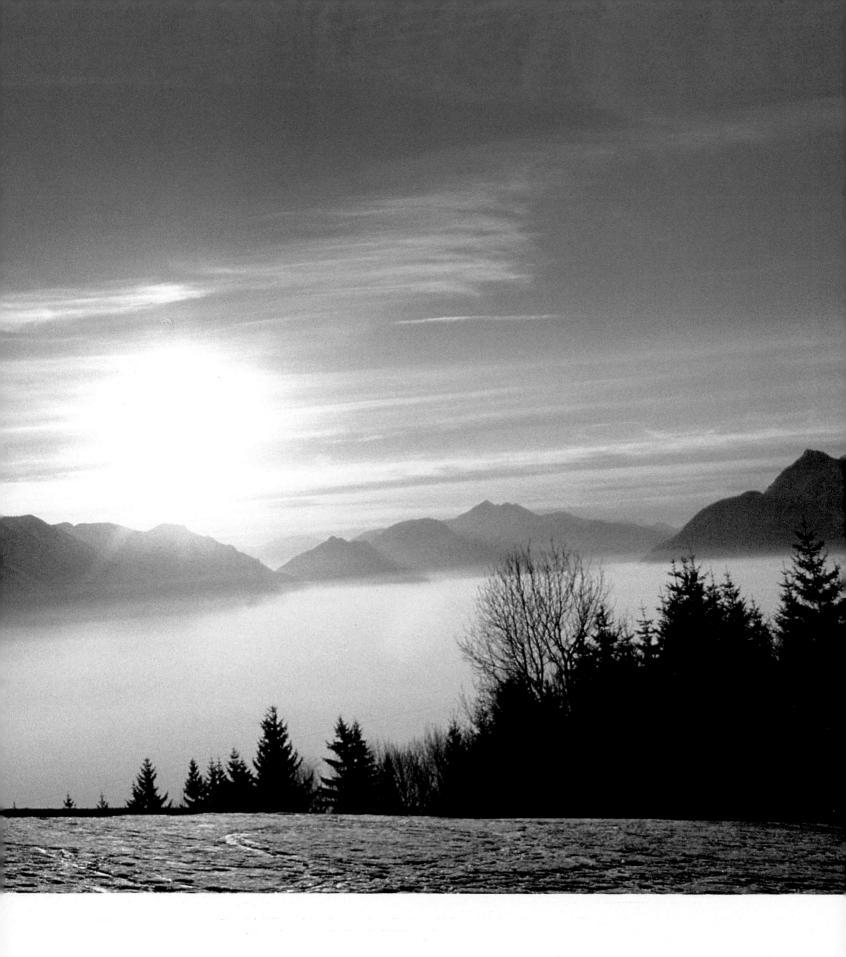

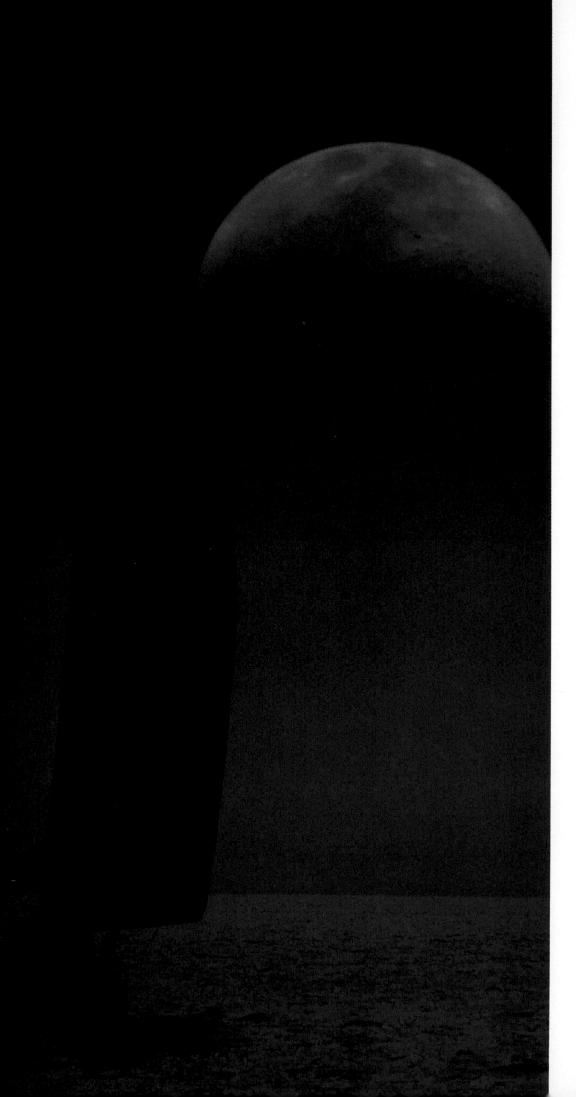

Best Seller #96
Total Sales: $9,855
Times Sold: 15
Average Annual Sales: $3,285
Average Sale Price: $657
Highest Single Sale: $1,500

"I took this shot of a sailing ship on Lake Pontchartrain in New Orleans, using very strong backlighting," explains photographer Larry Chiger. "That gave the image a monochromatic quality which I thought might lend itself to a special effect. So when I duped the image in the lab, I used a blue filter, and, as an afterthought, added a second shot—one of the moon. I experimented with composite photography on a regular basis for a while, but it's a specialty that takes a long time to master. Of all the composites I produced, there are only about a dozen—including this one—that I like."

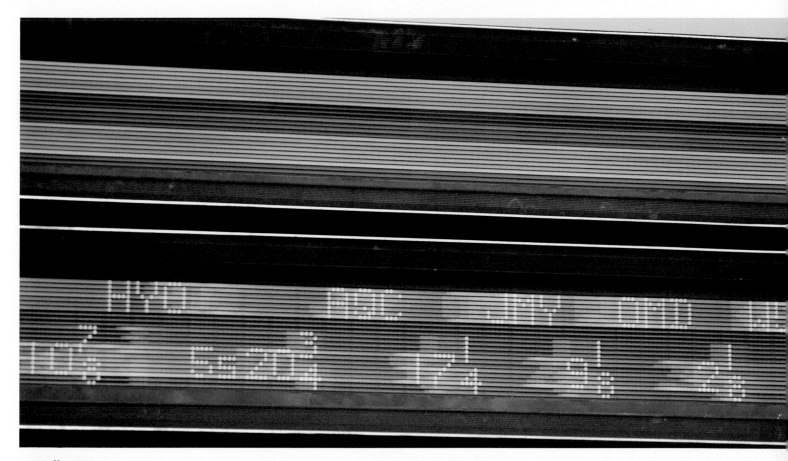

Best Seller #65
Total Sales: $12,687
Times Sold: 35
Average Annual Sales: $4,229
Average Sale Price: $362
Highest Single Sale: $750

According to photographer Larry Dunmire, "Sometimes a photographer is taken by the beauty of a subject, but, in the case of this electronic stock ticker, it was the sense of movement and light that caught my eye when I happened to accompany my father to his broker's office. I glanced up, watched the numbers on the board whizzing past me and realized that—even as my dad and his broker were talking—his stocks could be going up or down. To me, that symbolized not only the speed at which fortunes can be won or lost today, but also how fast the world in general changes."

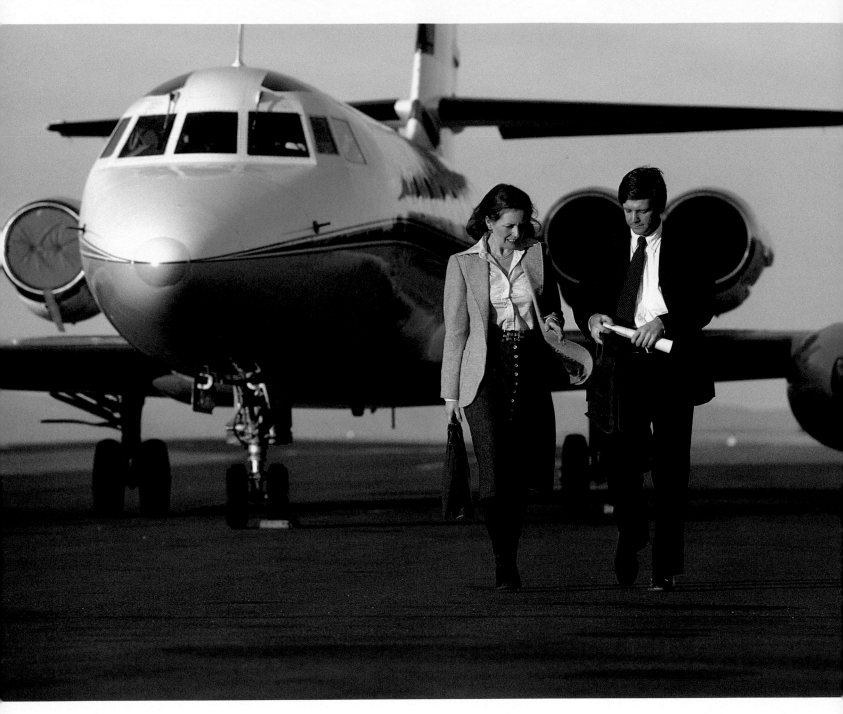

Best Seller #13
Total Sales: $28,438
Times Sold: 74
Average Annual Sales: $5,688
Average Sale Price: $384
Highest Single Sale: $850

A photo like this one can't just be snapped as a photographer deplanes. It requires permission from both the airport and the airline. "That's one of the advantages of living in a small town," says Charlottesville, Virginia photographer Robert Llewellyn. "Finding the decision-makers and obtaining their consent is relatively easy." Easy or not, that kind of initiative on the part of a photographer can certainly pay off in stock—as this best seller clearly indicates.

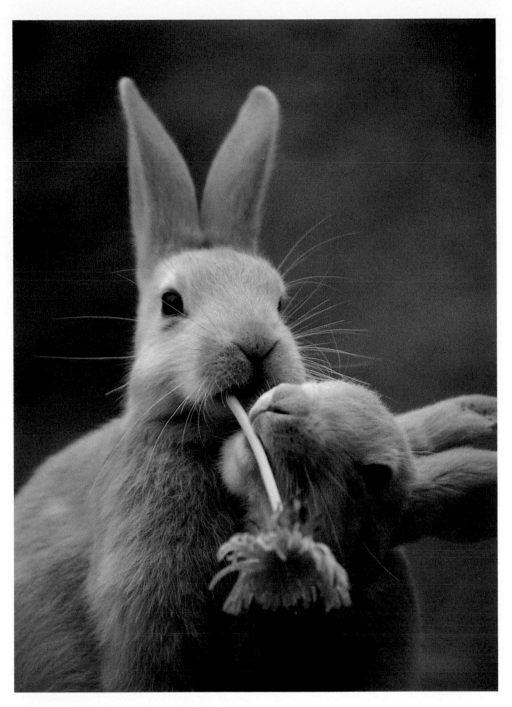

Best Seller #93
Total Sales: $10,500
Times Sold: 17
Average Annual Sales: $3,500
Average Sale Price: $618
Highest Single Sale: $750

"Like most of my shots, this one was taken on impulse," says Ron Dahlquist. "I was passing by the front yard of a house in Zermatt, Switzerland, when I saw a hutch of rabbits chewing on dandelions, completely oblivious to those of us passing by. Then I saw these two sharing. So I quickly snapped a couple of shots using a zoom lens. Of course, I thought the rabbits were cute—and perhaps there was a small statement to be found in their sharing—but I never dreamed the image would become a best seller."

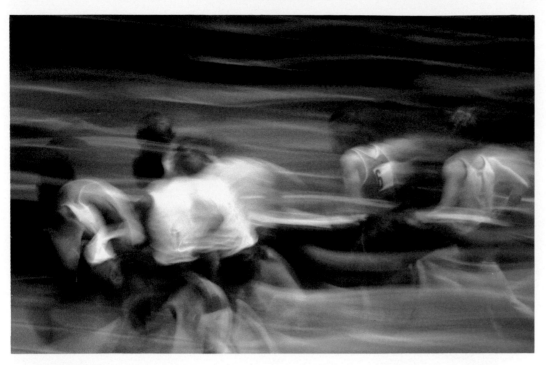

Best Seller #73
Total Sales: $11,490
Times Sold: 31
Average Annual Sales: $1,045
Average Sale Price: $371
Highest Single Sale: $1,250

"I'm a track aficionado and an ultra-distance runner," exclaims photographer Pablo Rivera. "So, as a photographer, when I shoot an event like this one, I try to capture the same sense of speed and competition and exhilaration that I feel as an athlete. To do this, I use film especially for slow motion, and shoot at a very low speed while panning the camera along with the runners. That's what produces the blurry effect." Another advantage of the "blurry effect" is that it frees the photographer from the need to obtain releases from the competitors—a feat which might be difficult to accomplish at a sporting event.

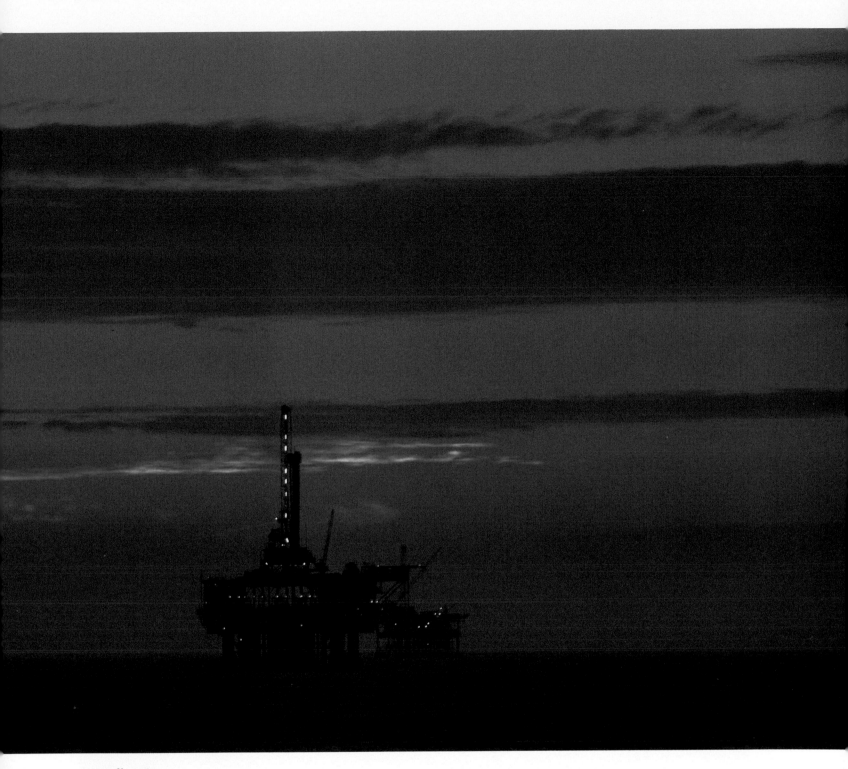

Best Seller #70
Total Sales: $11,650
Times Sold: 24
Average Annual Sales: $1,942
Average Sale Price: $485
Highest Single Sale: $1,500

Following the oil crisis of the 1970s, generic shots of the energy industry were everywhere. But few were better than this one of an off-shore drilling rig taken by Mick Roessler. A resident of Southern California— an area rich in deposits of on- and off-shore oil and gas—Roessler has achieved a well-deserved reputation among stock photographers for his energy-related imagery. Says Roessler, "I've taken hundreds of shots of rigs, pumpers and drillers over the years, but, every time, I try to find something different— something that will make each picture stand out, aesthetically and commercially.

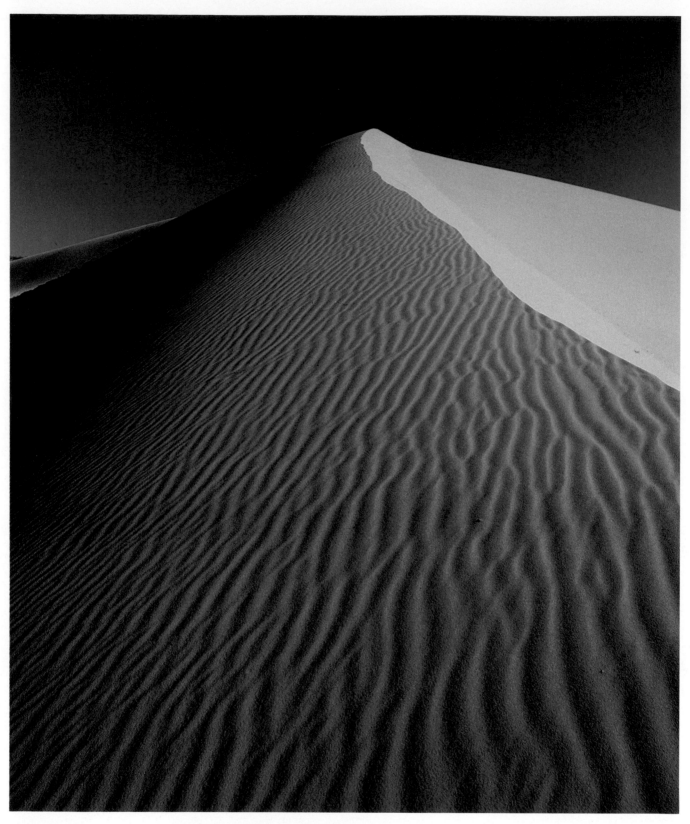

Best Seller #77
Total Sales: $11,250
Times Sold: 20
Average Annual Sales: $3,750
Average Sale Price: $563
Highest Single Sale: $2,500

This was shot by California photographer Mark Keller on one of his first trips to Death Valley—the site which inspired works by Ansel Adams, Edward Weston, Brett Weston and other noted photographers. Over the years, Keller has returned to Death Valley many times, recording more than five thousand images of the light and sand of the desert. This particular shot derives its strong graphic quality from the interaction of a giant sand dune—one side pristine, the other textured by the wind—with the deep blue desert sky.

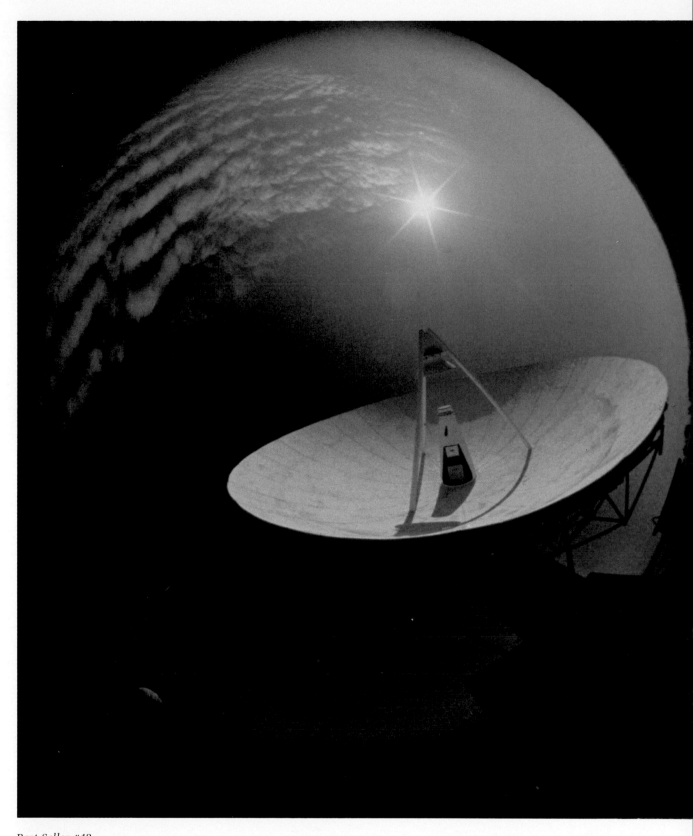

Best Seller #42
Total Sales: $16,484
Times Sold: 45
Average Annual Sales: $2,747
Average Sale Price: $366
Highest Single Sale: $850

In this image from NASA, the photographer used a fisheye lens to capture a satellite dish and the sky. It's a departure from the agency's conventional style and an effective choice—one that's proven very popular in recent years as the world has grown increasingly dependent upon instant telecommunications.

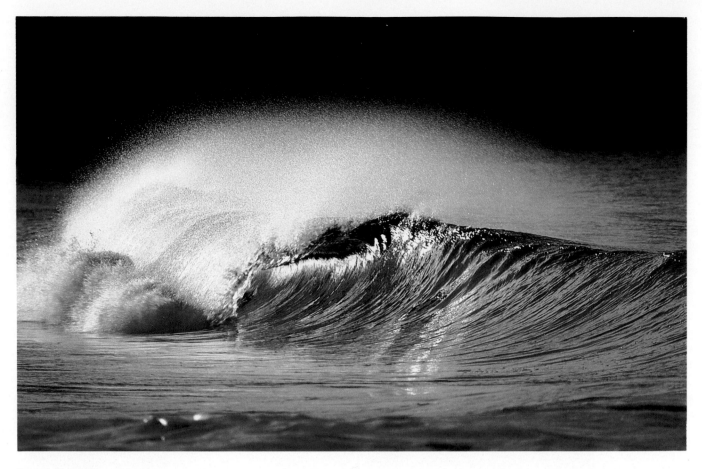

Best Seller #90
Total Sales: $10,707
Times Sold: 24
Average Annual Sales: $1,785
Average Sale Price: $446
Highest Single Sale: $1,500

The ocean—vital to the preservation of human life, source of electric power and outlet for pleasure and recreation. In this simple yet compelling composition, California photographer Woody Woodworth has captured all of the elegance and energy of the "bounding main" and—in the process—has created an image that meets the needs of environmentalists, the water sports industry and those in the business of hydroelectronics.

Best Seller #21
Total Sales: $24,017
Times Sold: 89
Average Annual Sales: $3,002
Average Sale Price: $270
Highest Single Sale: $750

Timing can often play a crucial role in the success of a stock photo. For example, in the last few years, as residential construction in the United States rose dramatically, the need for generic construction shots also increased. Among the most popular is this shot. Taken from above with the construction workers neatly framed within a wooden grid, it's different from the more conventional, straight-on shots, and, therefore, tends to attract a large number of users.

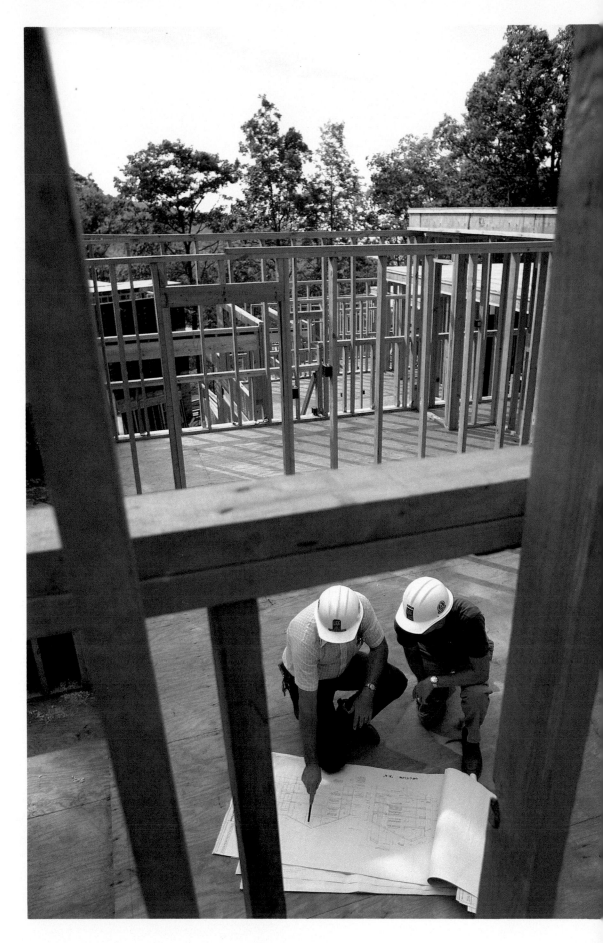

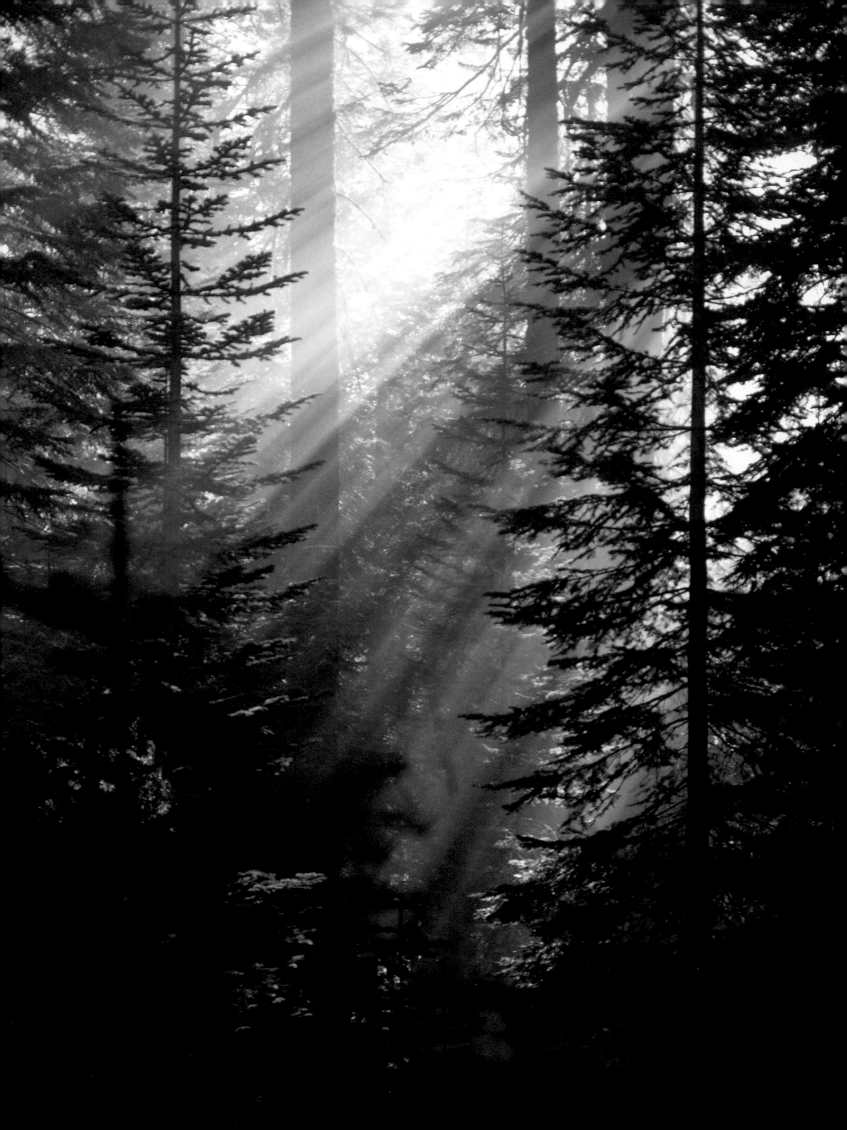

Best Seller #86
Total Sales: $10,850
Times Sold: 20
Average Annual Sales: $3,617
Average Sale Price: $543
Highest Single Sale: $1,000

Religious publishing accounts for a significant portion of the world's annual output of books, periodicals, calendars and greeting cards. But it is an industry that typically operates on a limited budget, so the availability of appropriate, low-cost imagery in stock is attractive to most religious publishers and institutions. This shot—with the rays of the early morning gently caressing the towering redwoods of California—provides a suitable backdrop for many an inspirational message.

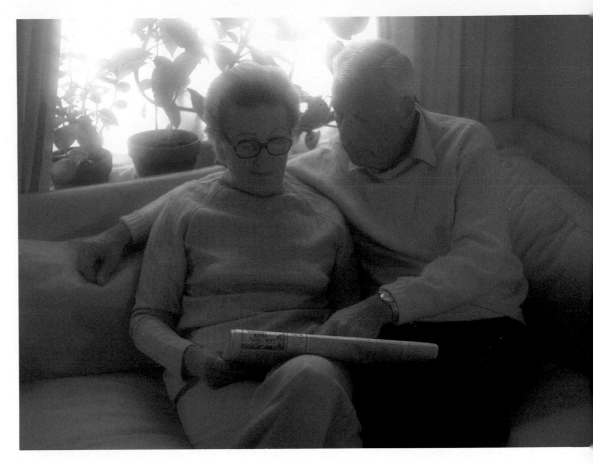

Best Seller #69
Total Sales: $11,659
Times Sold: 50
Average Annual Sales: $1,295
Average Sale Price: $233
Highest Single Sale: $1,500

Enterprising photographer Carla Moore took advantage of a parental visit to her Manhattan apartment to obtain this shot of a healthy, active elderly couple. "They were sitting together on the couch with the natural light from the window surrounding them," she says, "so I handed my mother-in-law the newspaper and asked her to pretend to be reading about a place they plan to visit. Except for that prop, however, the shot was completely unstaged. Even the complementary earth tones in their clothes—that just happened to be what they were wearing that day."

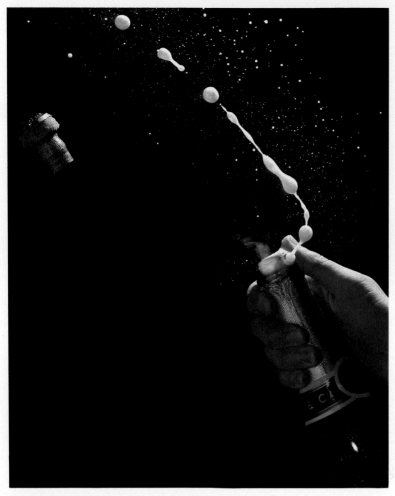

Best Seller #72
Total Sales: $11,500
Times Sold: 31
Average Annual Sales: $1,437
Average Sale Price: $371
Highest Single Sale: $750

Ah…a touch of the bubbly to say
"Congratulations"…"Good Luck"…
"Thank You," sentiments which
every company and institution must
express at one time or another.

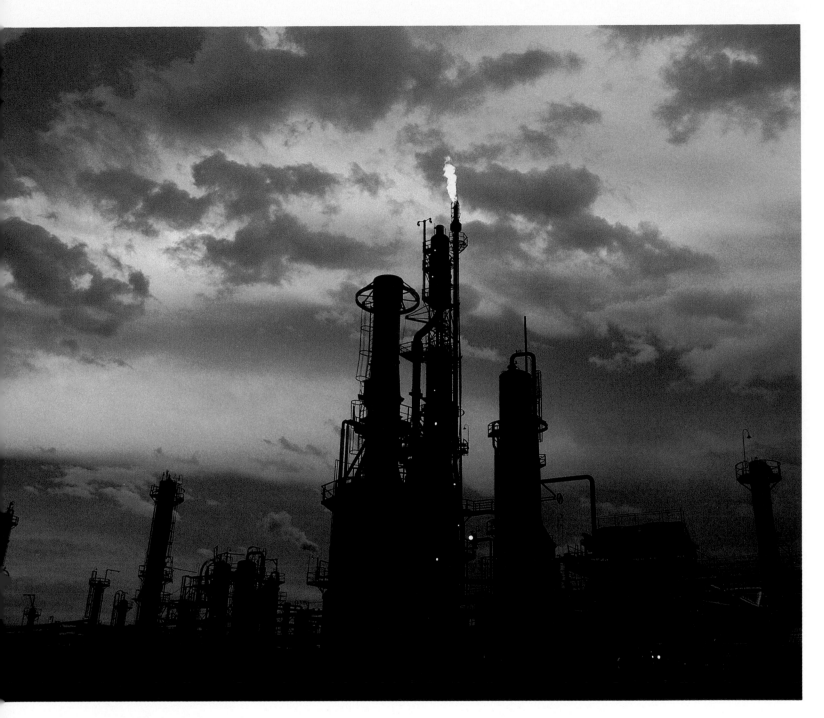

Best Seller #22
Total Sales: $23,418
Times Sold: 66
Average Annual Sales: $3,903
Average Sale Price: $355
Highest Single Sale: $1,250

Refineries are usually dull and
unattractive. But, by silhouetting this
edifice against a pink panoramic sky
and then shooting it from below to
emphasize the structure's height,
photographer Bill Fletcher succeeded
in turning a refinery into a towering,
romantic symbol of progress and
power. In the process, he created an
image that proved to be quite popular
during the oil crisis of the 1970s.

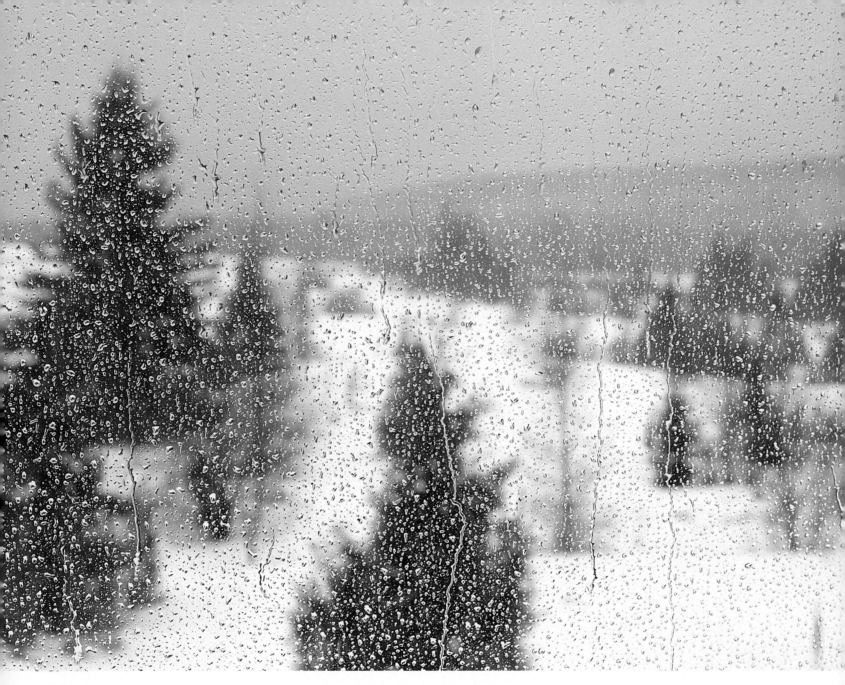

Best Seller #46
Total Sales: $16,037
Times Sold: 43
Average Annual Sales: $2,005
Average Sale Price: $373
Highest Single Sale: $1,200

None of the members of my staff wanted me to include this image in our catalog. They felt it lacked color and failed to communicate a single message quickly and clearly—two essential ingredients for a good stock photo. I agreed but I thought that the unusual composition—a snowy landscape shot through a rain-speckled window—might interest some of our clients. Still, when I decided to make this a catalog photo, I never expected it to have such widespread popularity. I certainly didn't expect it to generate over $2,000 a year for eight years!

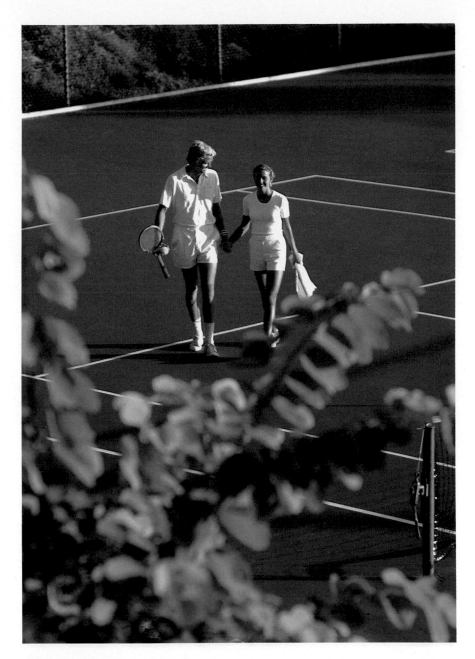

Best Seller #20
Total Sales: $24,066
Times Sold: 92
Average Annual Sales: $3,008
Average Sale Price: $262
Highest Single Sale: $600

Although this best seller was shot in Bermuda, it was carefully composed so that it could represent a tennis court anywhere in the world. Of course, it isn't tennis per se that makes this photo successful; it's what tennis represents—recreation, travel, lifestyle, togetherness, health and fitness. That's why banks, insurance companies and others offering such goods and services have chosen this photo. But it's proved most popular with the real estate industry. In fact, over 25 percent of all revenues have come from this field because, in today's leisure-oriented society, providing attractive recreational facilities sells a lot of homes and condominiums.

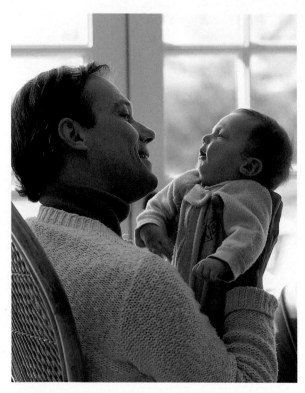

Best Seller #76
Total Sales: $11,378
Times Sold: 35
Average Annual Sales: $2,276
Average Sale Price: $325
Highest Single Sale: $550

In the early days of commercial stock photography, most photographers would have shot this straight-on with the father and son looking directly into each other's eyes. Today, photographers must be more creative than that. By moving to a different vantage point, they can still convey the same subject matter from a more interesting angle, and, in this case, with a more complementary light source—natural light from the French windows. By the way, the same father and son were shot in best seller #48 which was taken by another photographer about three months earlier.

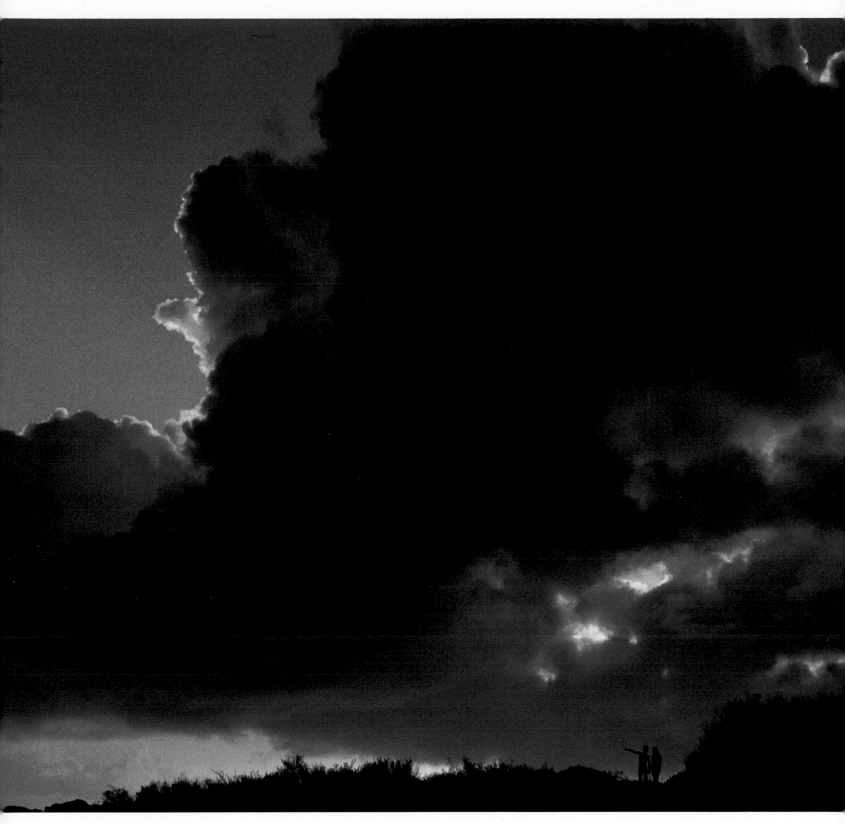

Best Seller #67
Total Sales: $12,481
Times Sold: 20
Average Annual Sales: $2,496
Average Sale Price: $624
Highest Single Sale: $1,650

From time to time, the photographers who work with us regularly ask what they might shoot that we would find useful at our agency. This photograph evolved from such a discussion, but, frankly, the result exceeded our expectations. Look at the shape of the clouds and that of the landmass. Their shapes are almost identical. And the people are situated in just the right place. Moreover, there's ample room to insert another photo, headline or copy.

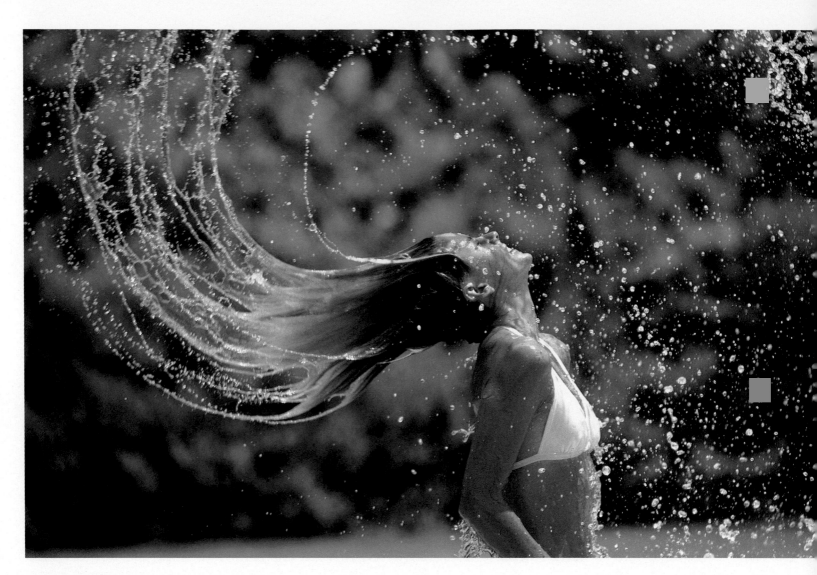

Best Seller #16
Total Sales: $26,710
Times Sold: 29
Average Annual Sales: $4,452
Average Sale Price: $921
Highest Single Sale: $8,000

"Getting a shot like this is fun," says photographer Robert Llewellyn, "because you're shooting something—drops of water in mid-air—that you really can't see with the naked eye. To accomplish this, you have to shoot very fast—maybe one-thousandth of a second. And it only works when the model puts her head back and thrusts her hair forward." With so many ad campaigns offering to make you feel better or improve the quality of your life, upbeat images like this one are in constant demand. But few capture the fresh, fun feeling better than this best seller, which conveys the exhilaration of a dip in cool water on a hot summer day.

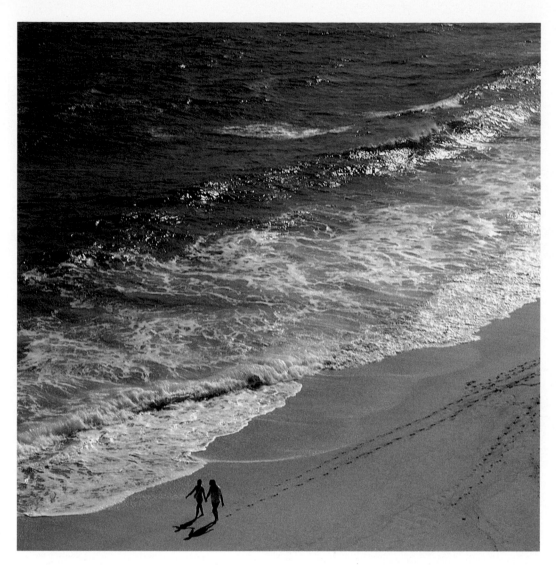

Best Seller #39
Total Sales: $18,150
Times Sold: 46
Average Annual Sales: $1,512
Average Sale Price: $395
Highest Single Sale: $2,500

This is one of my own photos, taken from the balcony of my hotel room in the Bahamas. I don't take many photos, but I do travel around the world, and try to take pictures wherever I go. However, being a photographer is just not in my blood. The best times to take photos are when I'm sleeping, eating, drinking or playing. And, if by accident I'm not indulging in one of those activities and fall into a great photo opportunity, my camera is invariably somewhere else!

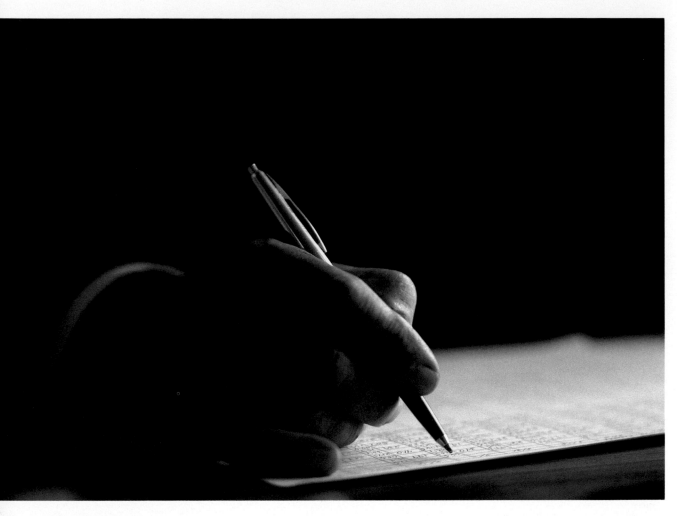

Best Seller #63
Total Sales: $12,775
Times Sold: 55
Average Annual Sales: $1,278
Average Sale Price: $232
Highest Single Sale: $600

From the confirmation of a decision
to the signing of an agreement or
contract; from the conclusion of a
deal to the writing of a letter or
memo; from the issuing of a purchase
order to the writing of a check—no
gesture says "decision-making" as
succinctly as the singular act of sign-
ing one's name.

Best Seller #14
Total Sales: $27,475
Times Sold: 48
Average Annual Sales: $4,579
Average Sale Price: $572
Highest Single Sale: $1,500

These clouds are so soft and billowy, the colors so pure, that the image is a natural for selling facial tissues, diapers and other paper products. It was shot in Bermuda by a New York photographer who says, "Hot, tropical climates tend to produce interesting cloud formations and intensely blue skies. You just don't get skies like that in Manhattan."

Best Seller #62
Total Sales: $12,813
Times Sold: 42
Average Annual Sales: $1,830
Average Sale Price: $305
Highest Single Sale: $600

In the early days of commercial stock photography, couples were almost invariably shot with a soft focus lens kissing or holding hands in very romantic settings. We helped to change that clichéd image with shots like this one, which shows two lovers simply walking on a rainy day through a wooded stretch of road, with the red of the woman's dress and the yellow of the umbrella providing brilliant pinpoints of color amidst an overall scene of green and gray.

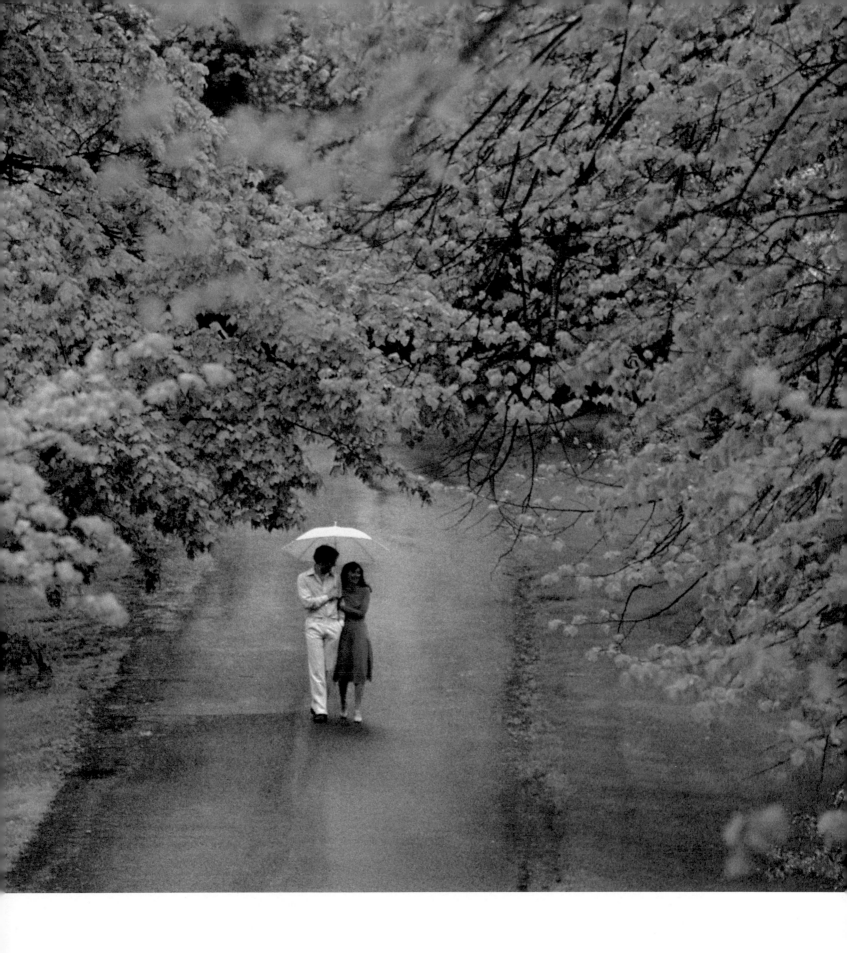

Best Seller #29
Total Sales: $21,970
Times Sold: 77
Average Annual Sales: $2,746
Average Sale Price: $285
Highest Single Sale: $750

This gentleman has the look of authority. He's just about to pull off his glasses, look you in the eye and say…well, he could be about to say almost anything. Which is why his picture has been used to sell every-thing from pharmaceuticals to a college education.

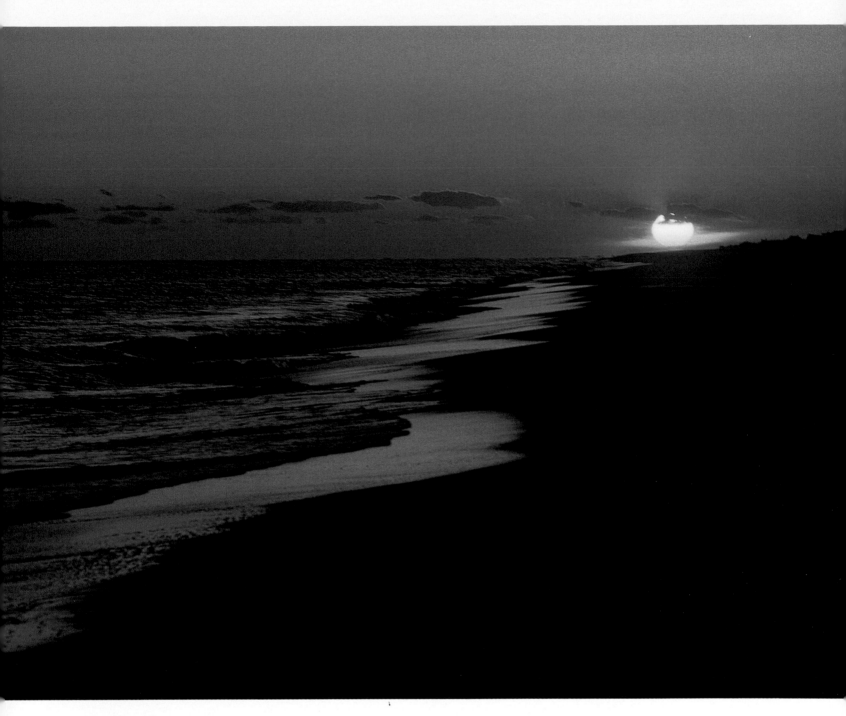

Best Seller #12
Total Sales: $29,547
Times Sold: 92
Average Annual Sales: $2,955
Average Sale Price: $321
Highest Single Sale: $1,500

While this photo suggests a warm, tropical evening, it was, in fact, shot in West Hampton, Long Island on a freezing winter day. Bill Beermann, a "weekend photographer," says, "I saw this scene through the lens, clicked the shutter...and prayed. My hands were frozen stiff. This was one of the first stock shots I ever did. Lucky for me it was two stops under-exposed—otherwise it would have been ordinary. I've probably shot three to four hundred sunsets and sunrises since then, but this one remains the best."

Best Seller #31
Total Sales: $20,929
Times Sold: 60
Average Annual Sales: $2,616
Average Sale Price: $349
Highest Single Sale: $2,500

Personally, I've never liked the composition of this photograph and I find the color—all that green—too intense. However, photographer Tom Rosenthal says that this organic marsh in Austria really *is* that green. And there's no denying the image's success commercially. It's been used for everything from an ad for a soap promising the feeling of spring to the cover of a book entitled *Be Still and Know*.

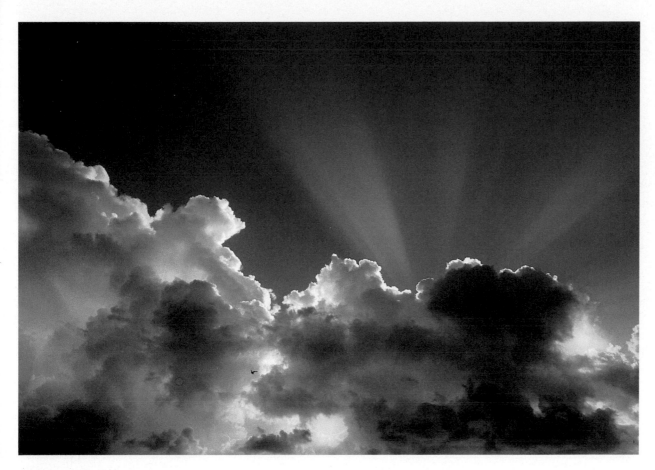

Best Seller #2
Total Sales: $66,174
Times Sold: 120
Average Annual Sales: $11,029
Average Sale Price: $551
Highest Single Sale: $4,500

The demand for this photograph seems almost endless. It's been used in ads, annual reports and several in-flight magazines. It's appeared on the cover of a paperback novel and on a label for cutlery. It's been featured on posters and TV spots, and licensed by banks, engineers and oil and insurance companies as well as an airplane manufacturer and the maker of digital equipment, hospitals, hotels— and even by the government. What makes it so popular? Partly it's the intense color of the sky and the shape of the clouds, but primarily it's because the rays of the sun radiating up from the center of the image suggest everything from hope to inspiration to a brighter tomorrow.

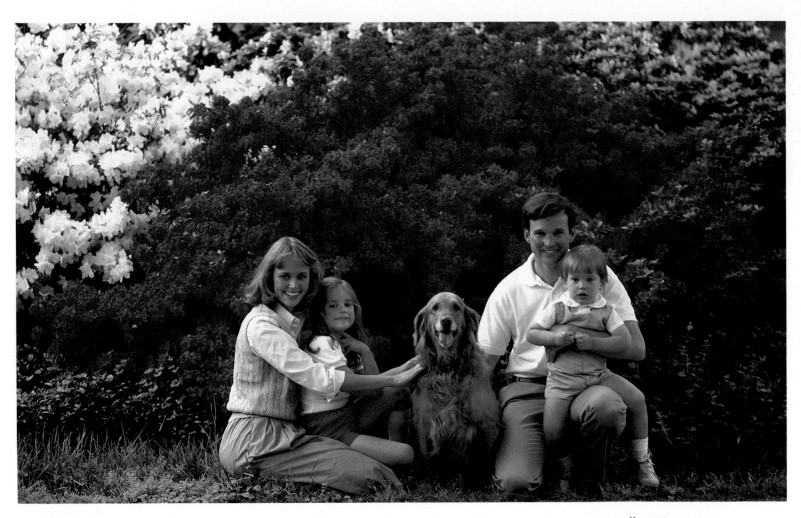

Best Seller #87
Total Sales: $10,849
Times Sold: 25
Average Annual Sales: $5,425
Average Sale Price: $434
Highest Single Sale: $1,000

Unlike most stock family shots which attempt to simulate spontaneous moments in everyday life, this is a portrait. It's the kind you might ask a neighbor to take in the backyard, or request a passerby to shoot on a family outing in the park. Of course, most of those shots don't turn out like this one. This is the *idealized* snapshot, featuring attractive parents, two adorable kids, a big, loveable dog and a breathtaking array of flowers in full bloom. It's the perfect image for advertisers who want to associate their product or service with a wholesome family feeling.

Best Seller #92
Total Sales: $10,500
Times Sold: 18
Average Annual Sales: $5,250
Average Sale Price: $583
Highest Single Sale: $1,500

Often an art director will provide an assignment photographer with explicit instructions on the contents and composition of an image *before* the shooting takes place. Sometimes he or she will even supply a sketch. The same can be true for assignment work in stock. For example, when I sent George Glod to the Caribbean, I asked him to give me shots that: a) were taken from a high vantage point; b) included palm trees in the picture plane; c) incorporated both surf and beach; and d) featured a couple in isolation, casually strolling through the scene. As you can see from the result, not only did he give me what I wanted—he did so with precision and his own special touch of inspiration.

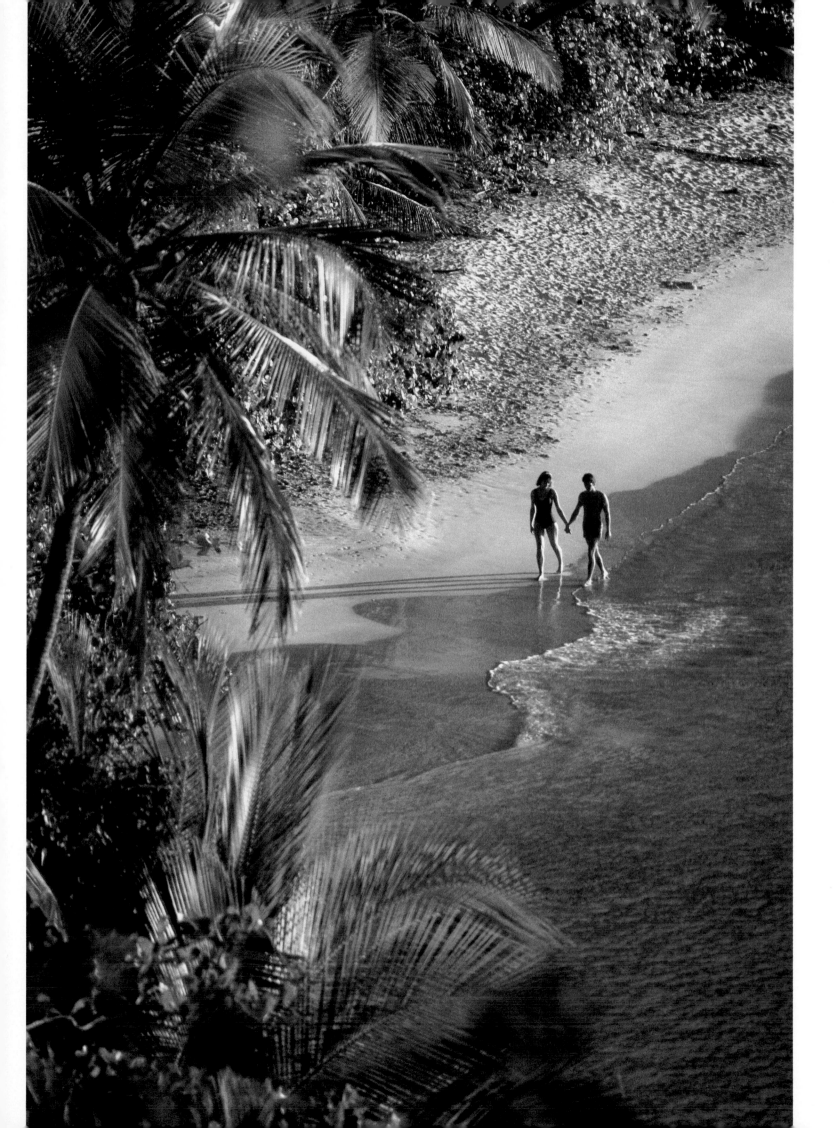

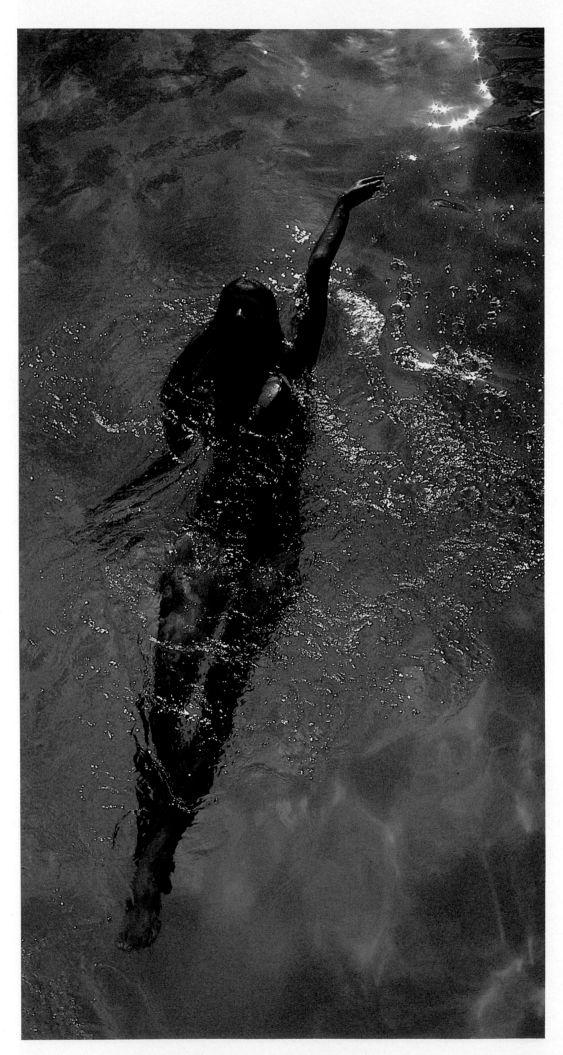

Best Seller #57
Total Sales: $13,724
Times Sold: 43
Average Annual Sales: $2,287
Average Sale Price: $319
Highest Single Sale: $1,800

Shooting from a distinctive bird's-eye perspective, photographer Scott Barrow has used the image of a girl, alone in a sea of aqua-green, swimming with ease and grace, to epitomize the wonderful, relaxing properties of water. It's no wonder, then, that local manufacturers of swimming pools alone have licensed the rights to this picture over half a dozen times.

Best Seller #78
Total Sales: $11,203
Times Sold: 45
Average Annual Sales: $1,400
Average Sale Price: $249
Highest Single Sale: $750

According to photographer Herb Levart, "I was shooting an assignment for an engineering firm when I realized that the three items you see—a calculator, a compass and a protractor—were to be found at virtually every station in the drafting room. I was intrigued by that, and by the shapes of the objects themselves. So I created a still life around them, using a schematic drawing as an anchor. When I got through, the process had not only helped me work through the concept for my assignment, but it also gave me a very nice generic statement about engineering that I thought might do well in stock." And indeed it has. It's not only been used in the promotional materials of many engineering and technical firms, it's also been featured in numerous trade journal articles and was on the cover of a brochure for an engineering school.

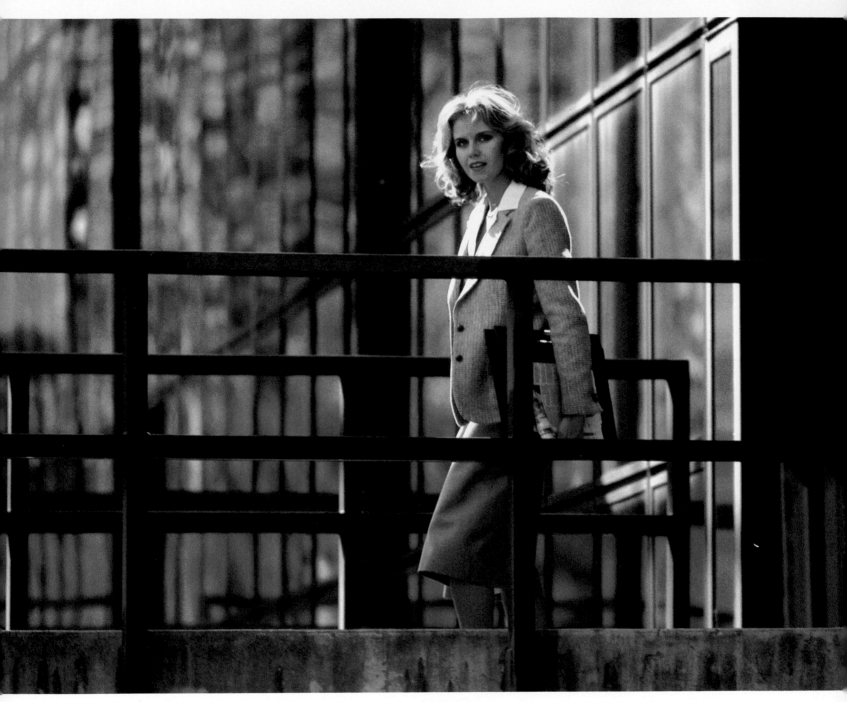

Best Seller #44
Total Sales: $16,450
Times Sold: 20
Average Annual Sales: $2,742
Average Sale Price: $822
Highest Single Sale: $750

More and more companies today are relocating from downtown high-rises to suburban office parks. To capitalize on this trend—as well as on the continuing need for shots of women in the workforce—we decided to shoot a series of outdoor photos at a Connecticut business center. Included were shots of this model who clearly looks like a young woman on her way up. This image was the most effective in the series because the photographer used the steel ribbing of the building and the handrails on the walkways to create a grid framing the model. He also adds a wonderful shimmer of color to the image by capturing the reflection of the fall foliage behind him on the building's glass front.

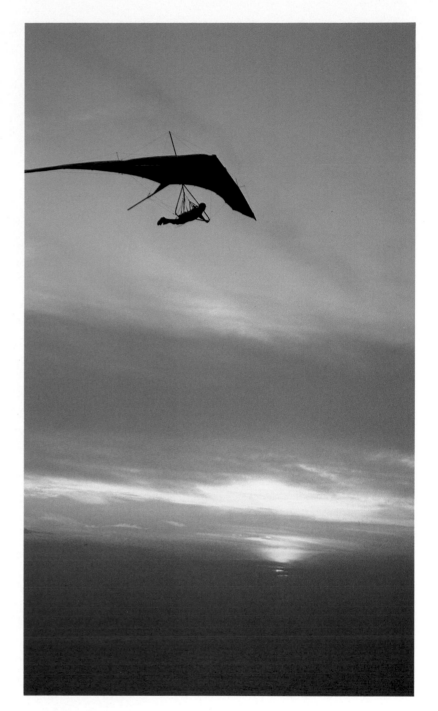

Best Seller #61
Total Sales: $12,880
Times Sold: 33
Average Annual Sales: $2,576
Average Sale Price: $390
Highest Single Sale: $2,250

For most of us, hang gliding is just a fantasy, too dangerous to really try. But what a wonderful sense of freedom and escape is suggested in this image…with lots of room for type and product insets besides.

Best Seller #56
Total Sales: $14,350
Times Sold: 36
Average Annual Sales: $2,392
Average Sale Price: $399
Highest Single Sale: $800

Solar light, heat and energy are crucial to life on this planet. And nowhere is the power and beauty of the sun more graphically depicted than in this simple but eloquent image. It's been used many times, not only by restaurants, hotels and cruise lines—which provide the pleasures that accompany bright warm sunshine—but also by battery manufacturers, electronics companies and others who use the sun's energy metaphorically to describe their own.

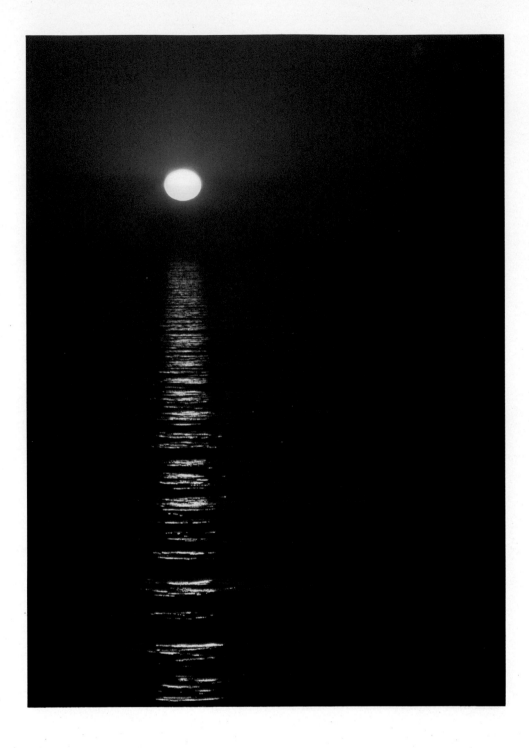

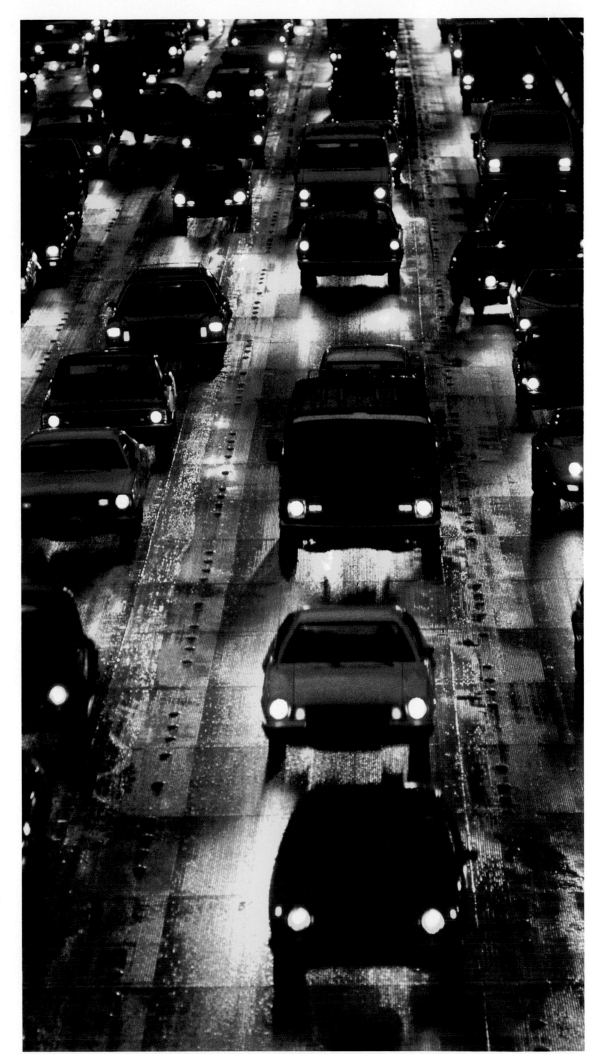

Best Seller #59
Total Sales: $12,968
Times Sold: 36
Average Annual Sales: $2,161
Average Sale Price: $360
Highest Single Sale: $600

Unfortunately, traffic jams are a fact of everyday life, presenting hazards and frustrations that are physical, emotional, practical—and even legal. That's why this best seller has been used by publications, institutions and corporations that—in one way or another—serve your health, your soul, your car or your rights—from the Church of Christ to the American Bar Association to *American Opinion Magazine.*

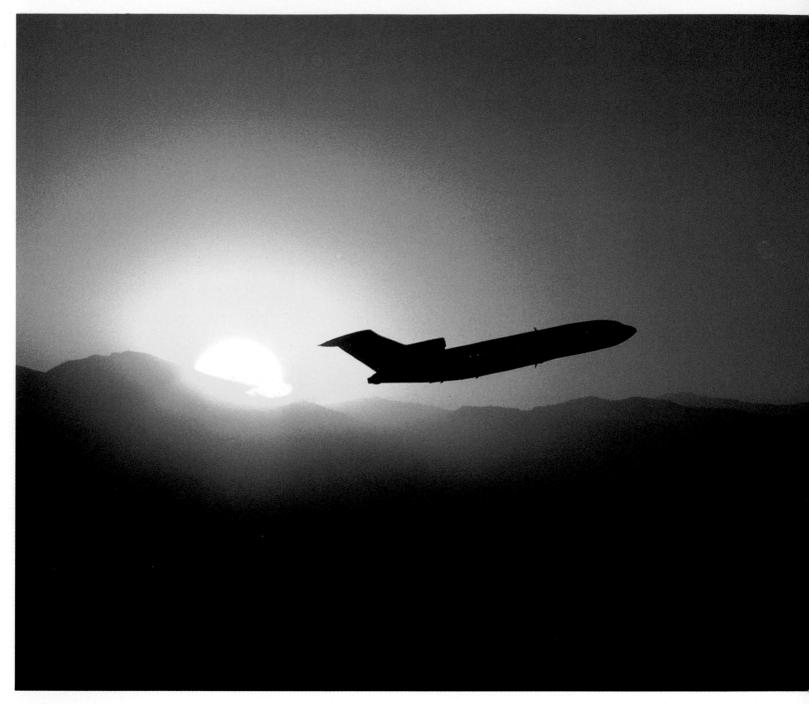

Best Seller #27
Total Sales: $22,578
Times Sold: 62
Average Annual Sales: $3,763
Average Sale Price: $364
Highest Single Sale: $650

In this shot of a plane just after takeoff, with the sun rising over the mountains of Colorado, photographer Bill Fletcher captured all of the romance and adventure associated with leisure-time travel. Silhouetting preserves the airline's anonymity, thereby expanding the marketability of the photo, and there's a lot of space to set type or insert other images.

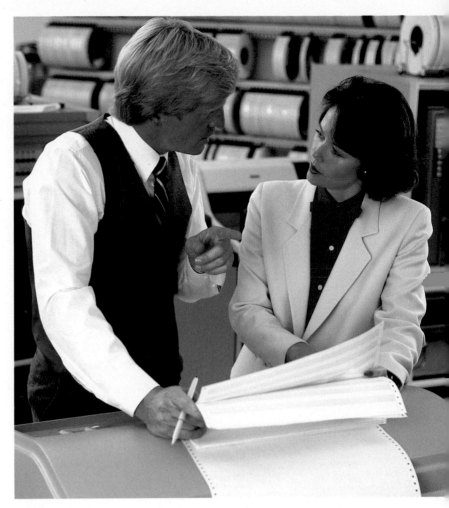

Best Seller #64
Total Sales: $12,764
Times Sold: 35
Average Annual Sales: $4,255
Average Sale Price: $365
Highest Single Sale: $1,000

When stock photography as a separate field was in its infancy, photographers had to use friends and relatives as models because most professionals refused to sign the kind of blanket-usage contracts that stock—by definition—required. Over the years, however, as stock began to provide more and more potential employment opportunities for models, this situation changed and, today, most stock agencies no longer have a problem getting professionals to pose for them. This session, showing executives using data processing equipment, was an early example of an agency's use of professional models, and I think it's proved to be a rewarding experience for all concerned.

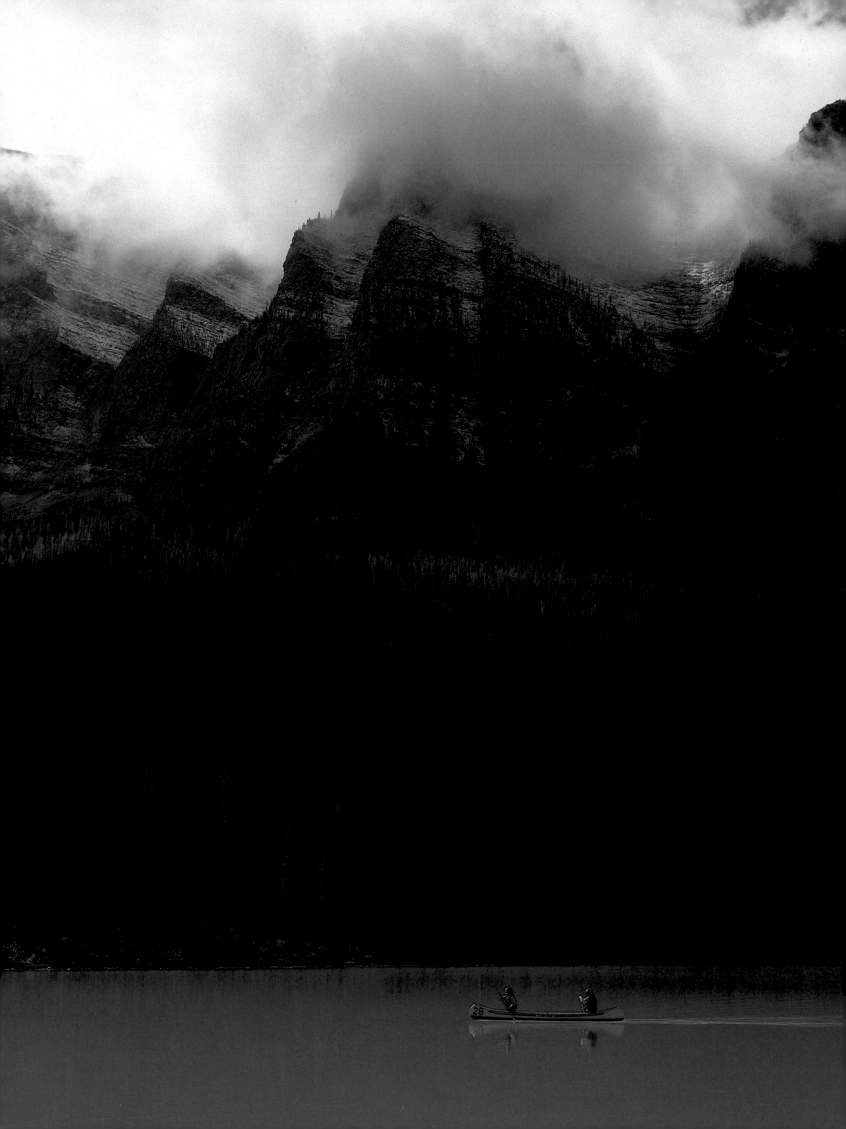

Best Seller #82
Total Sales: $10,927
Times Sold: 25
Average Annual Sales: $3,642
Average Sale Price: $437
Highest Single Sale: $650

Steve Vidler's photo of Lake Louise, Canada provides an idyllic view of the outdoor life—a clear, green lake, pine trees and majestic mountain peaks. This evocation of a place where one can commune with nature, contemplate private thoughts or share the company of a loved one has been used to grace the cover of a telephone directory, a calendar and numerous brochures.

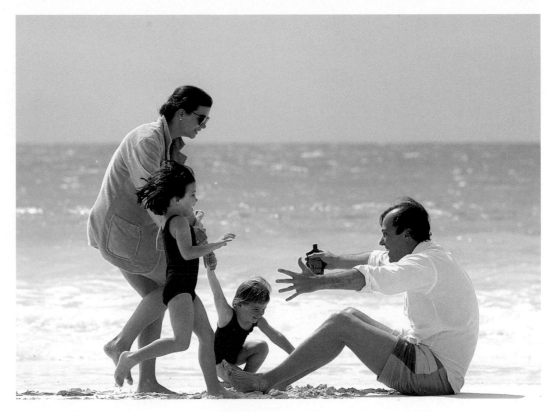

Best Seller #40
Total Sales: $17,475
Times Sold: 43
Average Annual Sales: $2,913
Average Sale Price: $406
Highest Single Sale: $1,200

This image of a father, with his arms open wide to receive his family—suntan lotion at the ready—is enormously appealing for banks, insurance companies and other businesses that offer family protection. Of course, the charm and spontaneity of the scene, its locale and the brightly colored bathing suits also make this a popular image with hotels, fast-food restaurants and other consumer-oriented advertisers.

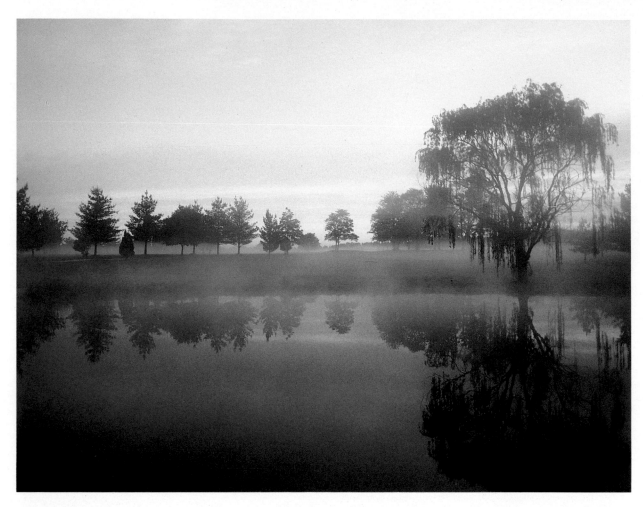

Best Seller #95
Total Sales: $10,050
Times Sold: 17
Average Annual Sales: $2,010
Average Sale Price: $591
Highest Single Sale: $1,250

Scott Barrow told me, "I spent a considerable amount of time over a two year period shooting the natural splendors of Virginia for the Economic Development Authority. This particular shot was taken on a golf course in Vienna, Virginia. I think it captures much of what the area has to offer—unpolluted skies, lush vegetation and a calmer way of life than that found in some of the nation's larger urban centers. It was a highly successful campaign, resulting in a ten-fold increase in new business to the area." It also produced a very popular stock photo. With its subject matter—the start of a fresh, new day—and its soft, relaxing colors, this photo is an appropriate image for ads, brochures, calendars, greeting cards and framed enlargements.

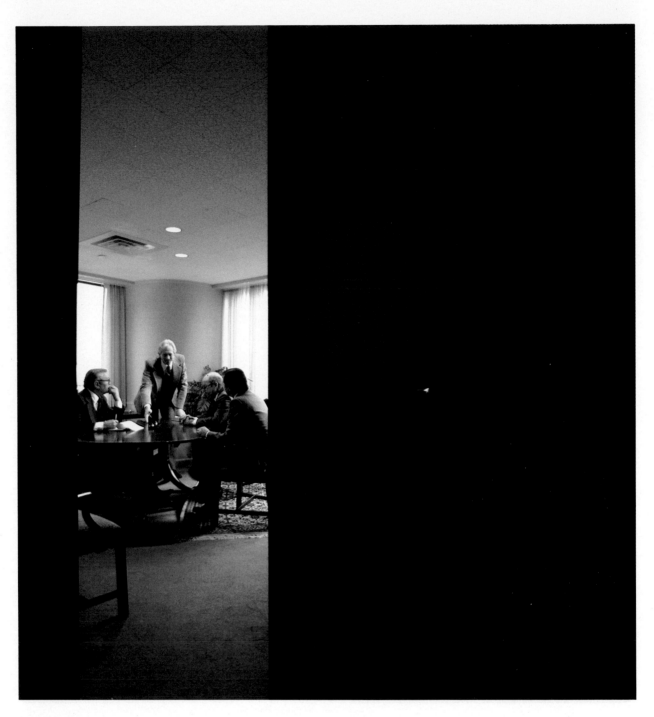

Best Seller #58
Total Sales: $13,423
Times Sold: 39
Average Annual Sales: $4,474
Average Sale Price: $344
Highest Single Sale: $550

In this best seller, photographer Robert Llewellyn invites us to "eavesdrop" on an important business meeting. Using an open door to frame the scene, the photographer has focused attention tightly on the action while maintaining his distance so that these "businessmen" can remain relatively anonymous. The result is an interesting composition—one that some of the nation's leading banks, insurance companies and manufacturers have used to illustrate teamwork and the decision-making process.

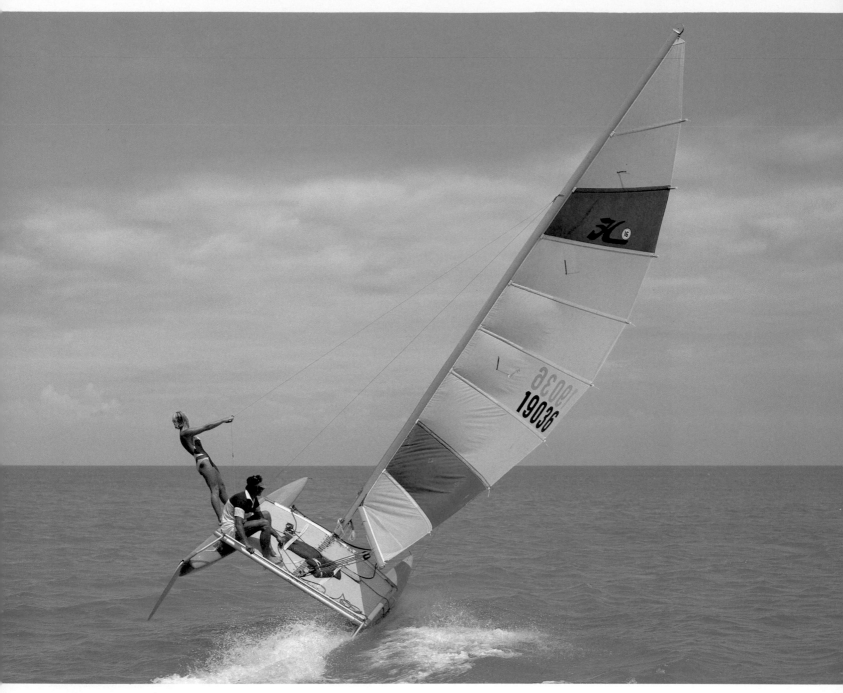

Best Seller #98
Total Sales: $9,500
Times Sold: 13
Average Annual Sales: $3,167
Average Sale Price: $731
Highest Single Sale: $1,400

For an action shot, there is a remark-able compositional balance in this image taken by the famous Japanese photographer, Tsuneo Nakamura. Look at the angle at which the cata-maran is tilting! And look at the counter-balancing angle of the woman on the other side. Add to that the boat's bright colors, the water's inviting clarity and the blue expanse of sky and you have an image well-suited for use in promoting tourism, water sports and leisure-time activities in general.

Best Seller #94
Total Sales: $10,350
Times Sold: 16
Average Annual Sales: $3,450
Average Sale Price: $647
Highest Single Sale: $1,250

With the end of the recession in the early 1980s, a new, upwardly-mobile consumer group called "Yuppies" emerged to become a significant target market for many of today's products and services. To help advertisers and publishers address this new audience, we had to acquire a whole new series of images. This couple—chosen by the marketplace 16 times in three years—personifies the Yuppie lifestyle. And it probably doesn't hurt that he looks a bit like Superman!

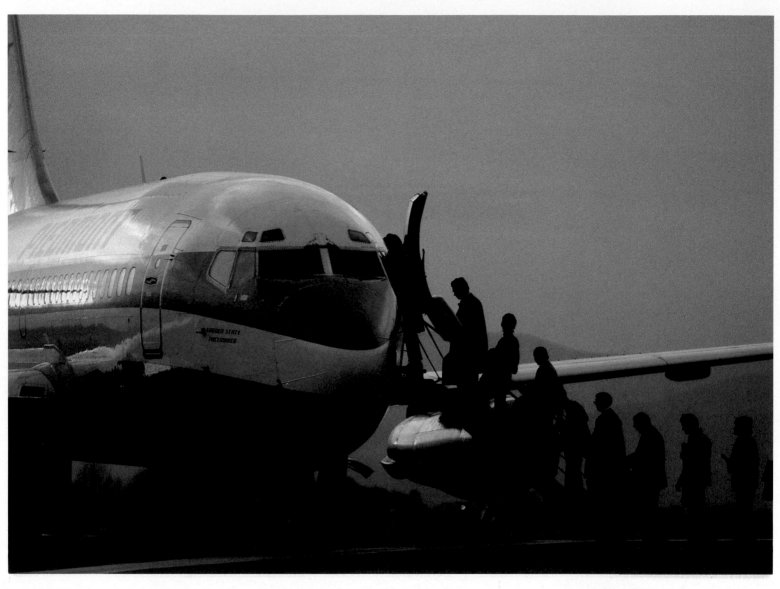

Best Seller #35
Total Sales: $19,604
Times Sold: 70
Average Annual Sales: $2,178
Average Sale Price: $280
Highest Single Sale: $750

The universality of an image is enhanced when its subject is anonymous. That's why this photo was carefully composed to silhouette the passengers and to conceal the airline's logo. But, even in silhouette, it's readily apparent that most of the individuals waiting to board this plane are business people. Since corporate travelers constitute a clearly defined target market for a variety of advertisers, this photo has been in constant demand for nearly a decade, and has been used to sell everything from clothing to credit cards to convention sites.

Best Seller #60
Total Sales: $12,957
Times Sold: 21
Average Annual Sales: $6,478
Average Sale Price: $617
Highest Single Sale: $1,200

For photographers, air travel provides a wonderful opportunity to shoot otherwise unobtainable shots—like this one, the highest grossing image per year. That's why photographers in-the-know plan their flights in advance. They decide which side of the plane will yield the best views. They make sure to get a window seat. And they always keep their cameras close at hand. Of course, even the best prepared photographer needs luck to get a good shot. After all, the speed of the airplane and the rapid movement of the clouds can cause a terrific photo opportunity to vanish in an instant. In addition, the window can be dirty. The double panes of glass can filter out too much light. And the weather can be unfavorable. In this case, luck, skill and preparedness paid off with a real winner!

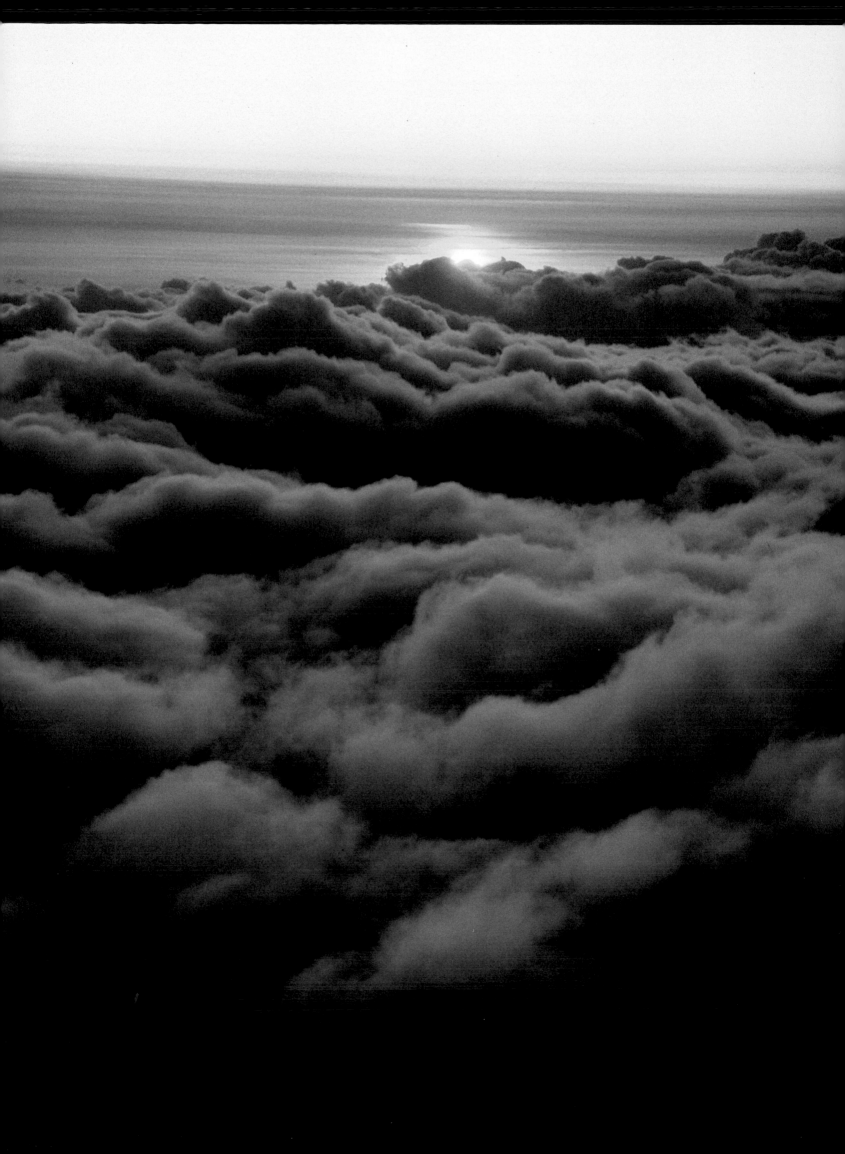

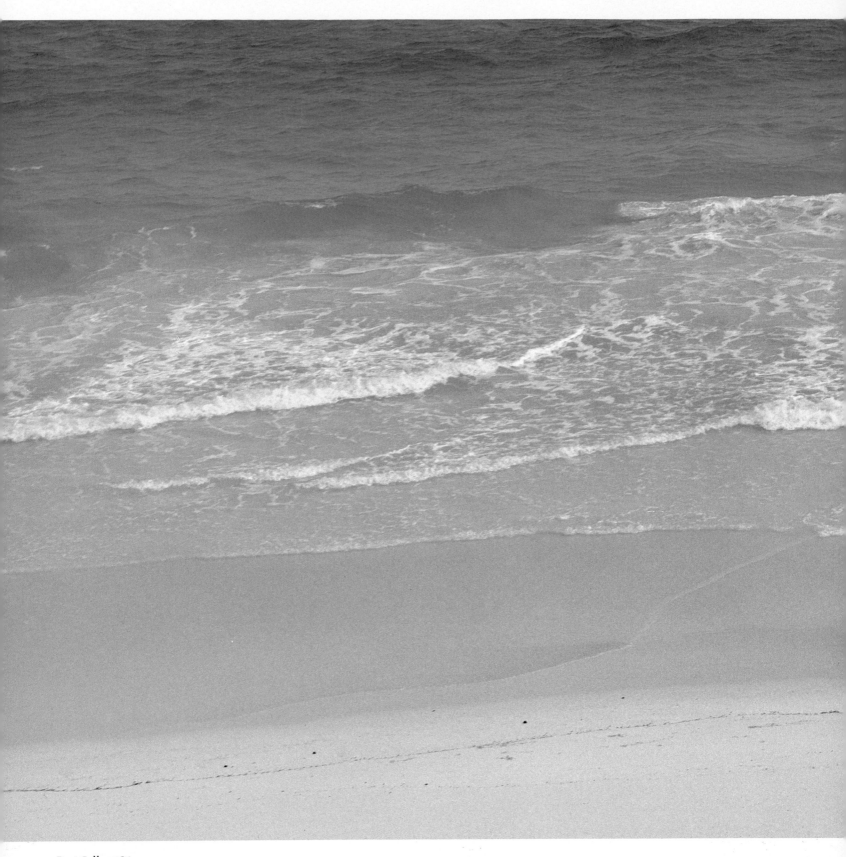

Best Seller #81
Total Sales: $10,945
Times Sold: 28
Average Annual Sales: $1,824
Average Sale Price: $391
Highest Single Sale: $1,250

A couple walking along the beach is one of the most commonly used stock photo situations. However, this one—taken in Bermuda—stands apart from most because it was taken from an unusually steep elevation.

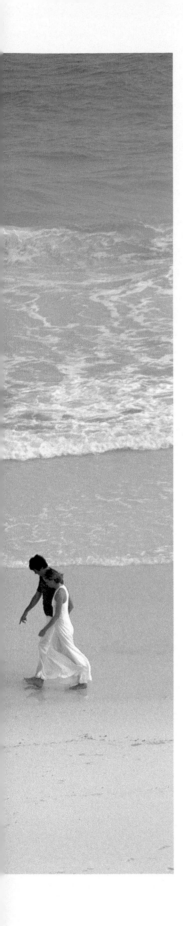

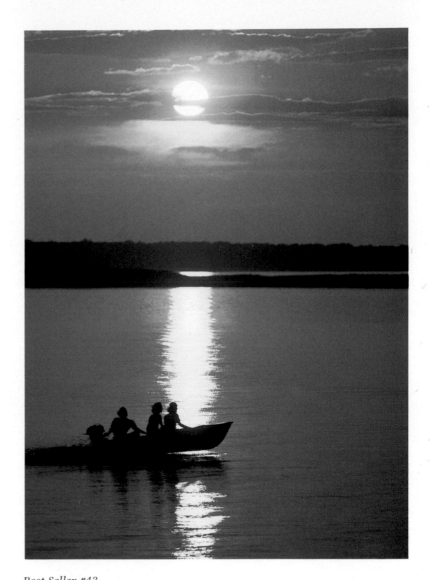

Best Seller #43
Total Sales: $16,461
Times Sold: 41
Average Annual Sales: $2,744
Average Sale Price: $401
Highest Single Sale: $1,000

Many of the elements of good stock photography come together in this image: simplicity, an effective use of silhouettes, a limited color palette and a popular subject—family together-ness. As a result, this photo has marketability, particularly among religious institutions, the travel industry and those selling health and fitness.

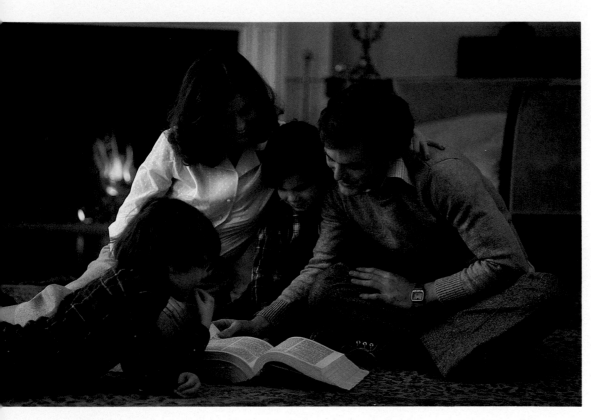

Best Seller #54
Total Sales: $14,510
Times Sold: 22
Average Annual Sales: $3,627
Average Sale Price: $660
Highest Single Sale: $1,700

"I'm a skier myself," says photographer Ron Dahlquist. "I think you have to be one in order to photograph the sport effectively. You also can't get to the places where the good photo opportunities are if you can't ski to them yourself. Of course once you get there, you have to wait and wait and wait for the right combination of light, snow...and action. During my career, I've taken thousands of ski photos—that's primarily how I earn my living. Currently more than 35 of my ski shots are being used in posters and post cards alone."

Best Seller #7
Total Sales: $39,210
Times Sold: 122
Average Annual Sales: $5,601
Average Sale Price: $321
Highest Single Sale: $2,500

According to photographer Robert Llewellyn, "I spent one winter's day at a friend's home on Long Island shooting this foursome—the homeowner's kids and a male and female model—in a variety of family-oriented situations. For this particular shot, I used primarily natural indoor lighting, augmented by an amber filter to bathe the scene in a warm, even glow. I prefer natural lighting to strobes so I can see what I'm shooting and the models can see each other. And I like the softer focus natural lighting provides—particularly for a scene like this one. But natural lighting does present one drawback—you have to shoot at a very slow shutter speed. That means exposing a lot of film because the models will invariably move in some of the shots." The result in this case, however, was worth the effort—a very naturalistic family scene, superior in composition and technique to many of the other family shots available in stock.

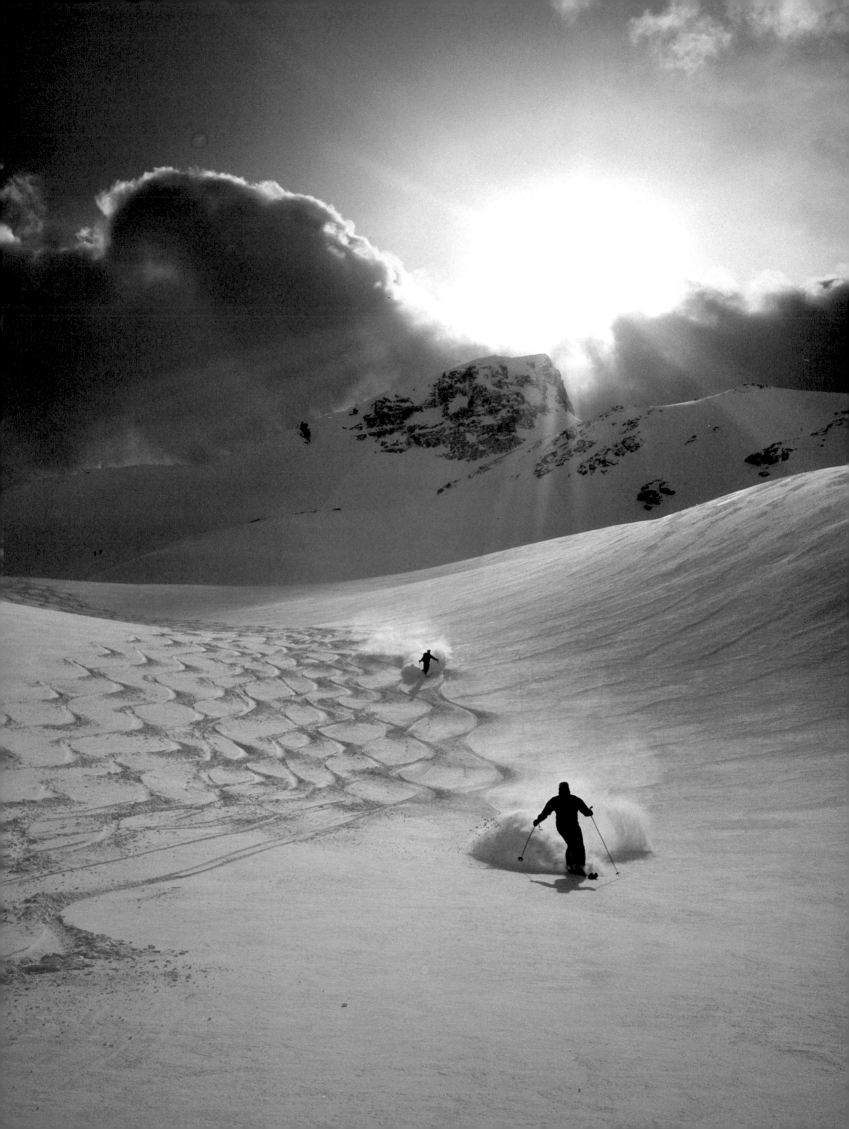

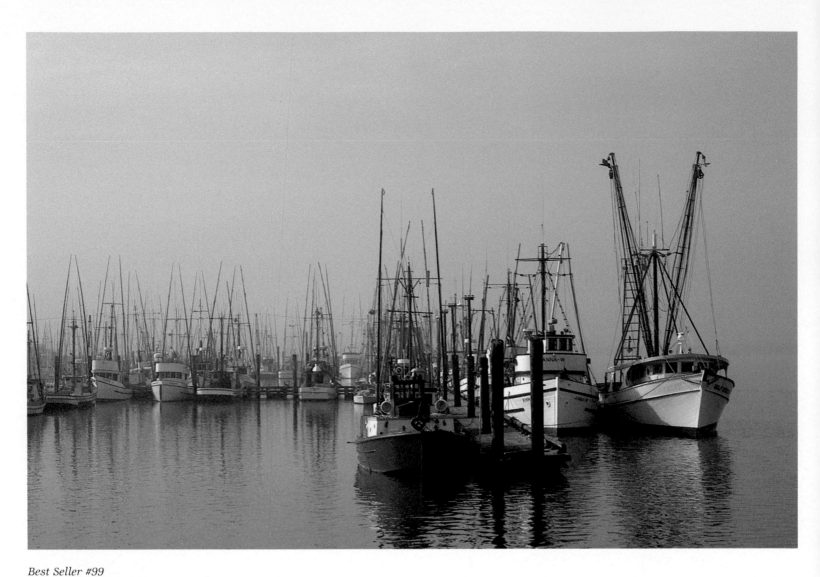

Best Seller #99
Total Sales: $9,200
Times Sold: 16
Average Annual Sales: $3,067
Average Sale Price: $575
Highest Single Sale: $1,500

Many of the photographs that are enlarged, framed and mounted on office room walls come from stock. This scenic vista, for example, is very popular among interior decorators. It provides a view that's easy on the eyes. The colors are primarily neutral so the image will blend in with almost any room's color scheme. And the subject matter—a moment of complete serenity in a New England harbor—provides a relaxing respite for office workers on-the-go.

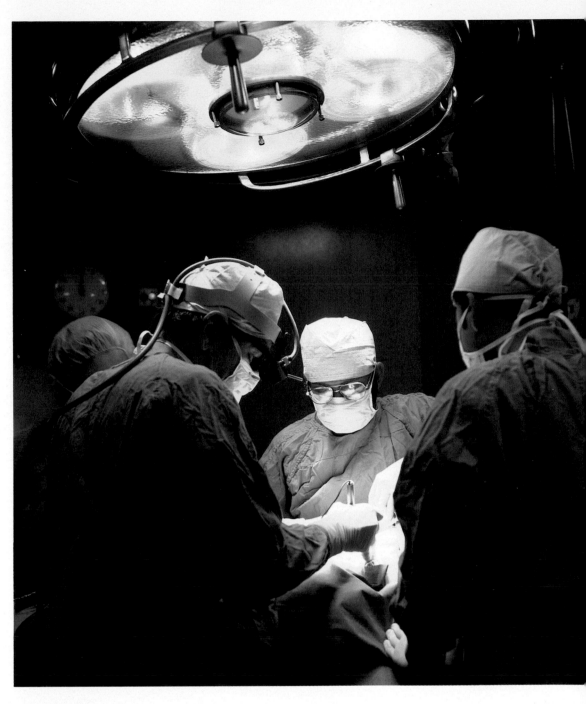

Best Seller #32
Total Sales: $20,801
Times Sold: 64
Average Annual Sales: $4,160
Average Sale Price: $325
Highest Single Sale: $880

"When I asked a surgeon and family friend if I might photograph him at work, I had never witnessed a surgical procedure before," explained photographer Tom Rosenthal. "The first thing I had to figure out was a way to combat the lighting problems caused by the operating room's very bright overhead lights which tend to cast everything in a greenish tint. I ended up using a hand held flash and a 30 magenta filter. Then I had to be very conscious about staying out of the way of the doctors who were confronting a life-and-death situation. But, for me, the biggest problem was dealing with the sight of a great deal of blood. I found that, by viewing the situation only through the lens of the camera, I could remain objective and concentrate on my work. It's creating—and meeting—challenges like this that, in my opinion enable a photographer to grow."

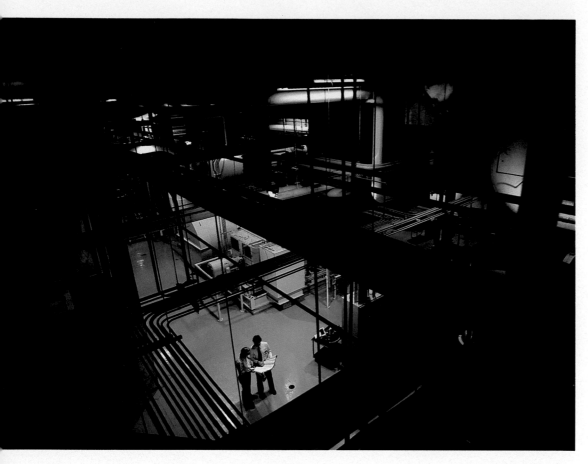

Best Seller #51
Total Sales: $15,235
Times Sold: 42
Average Annual Sales: $2,539
Average Sale Price: $363
Highest Single Sale: $1,50

Just a glance at this image gives the viewer a sense of the challenge, endurance and fun associated with waterskiing. That makes this photo very popular with real estate firms offering water sports facilities; with those involved in travel and recreation industries; and with camera companies featuring fast-action capabilities.

Best Seller #8
Total Sales: $33,814
Times Sold: 116
Average Annual Sales: $4,227
Average Sale Price: $292
Highest Single Sale: $1,750

Says photographer Robert Llewellyn, "To capture the synergy between technology and the worker of today, I positioned myself on the catwalk of a Virginia factory and used its overhanging cables and girders to frame the workers below. The grid that this equipment formed and the vast expanse of machinery on the ground floor strongly suggested the complex—even megalithic—quality of the environment. But, at the time, the soft colors—particularly the blue tiling—and the ease of the workers in their space, indicated that the human factor had not been lost—that it could even flourish amidst the wonders of technology."

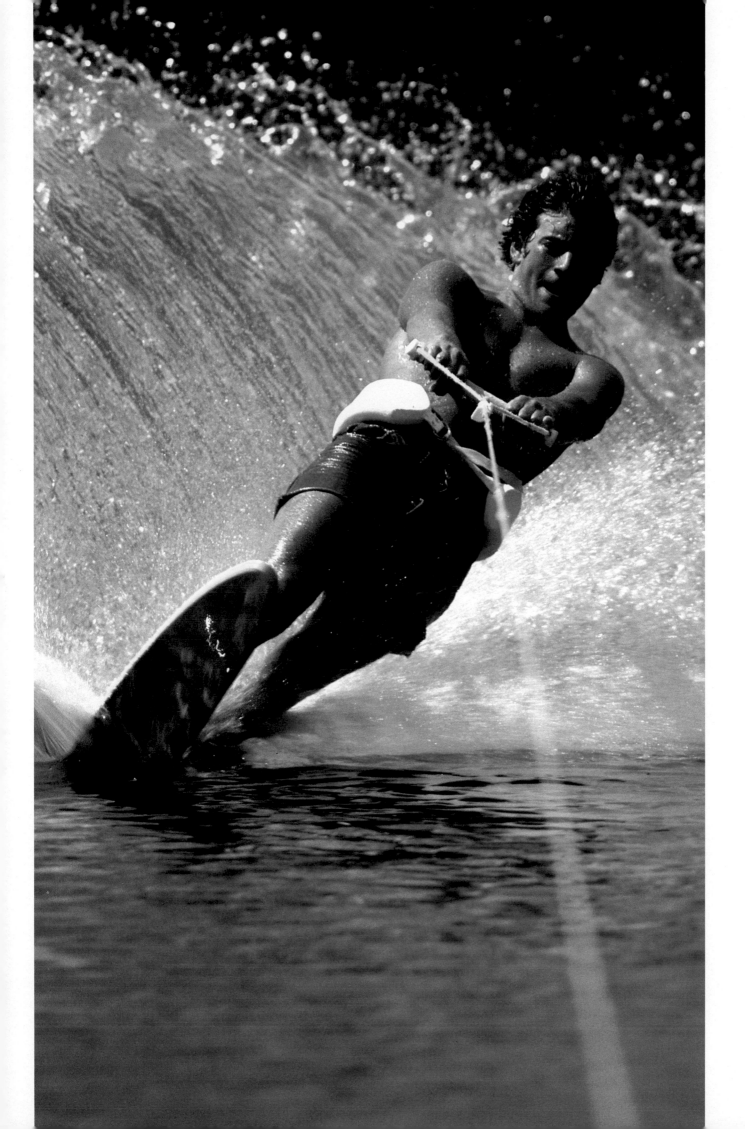

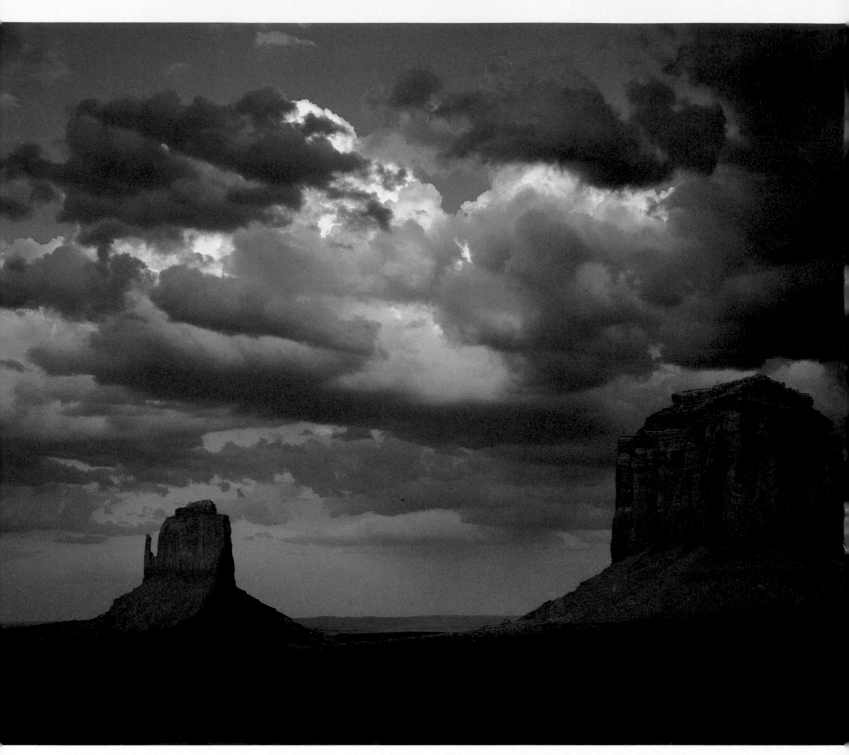

Best Seller #88
Total Sales: $10,800
Times Sold: 21
Average Annual Sales: $3,600
Average Sale Price: $514
Highest Single Sale: $1,000

In recent years, a new type of professional photographer has emerged—one who specializes in shooting photos for stock. Among this new breed is the creator of this shot, Steve Vidler. Vidler literally travels the globe capturing the wonders of the world—large and small—for agencies like Four By Five. A pioneer in the field, Vidler is perhaps the most successful travel stock photographer in the world today.

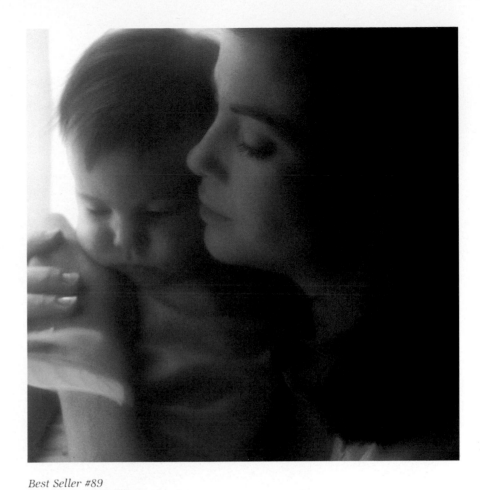

Best Seller #89
Total Sales: $10,742
Times Sold: 27
Average Annual Sales: $1,074
Average Sale Price: $398
Highest Single Sale: $2,200

"Sometimes, it's not the skill of the photographer that makes a good photo," says the creator of this image, William Beermann, modestly. "It's the situation or the models. This, for example, was one of my very first attempts at stock photography, and, to tell the truth, I didn't really know what I was doing. But I saw my wife holding our child, bathed in a warm natural light, a wonderful interaction developing between them, and I knew that all I had to do was set the needle in the middle, apply Vaseline™ to the filter to create a soft focus and click the shutter."

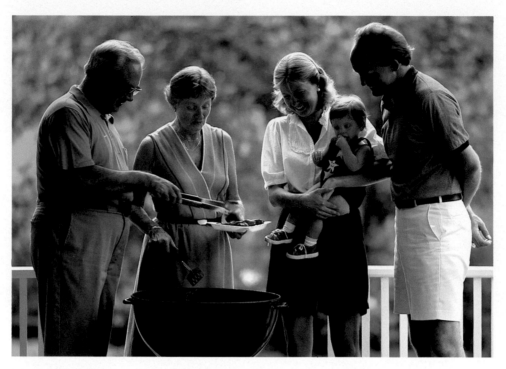

Best Seller #79
Total Sales: $11,193
Times Sold: 28
Average Annual Sales: $5,597
Average Sale Price: $400
Highest Single Sale: $1,500

Over the years, numerous requests for photos depicting three generations have come to us from religious institutions and insurance companies, both of which deal—in very different ways—with the continuity of family life. To meet these requests, we commissioned this shot, in which a typical American pastime—the barbecue—was used as a vehicle to illustrate the bonds between a child, his parents and grandparents.

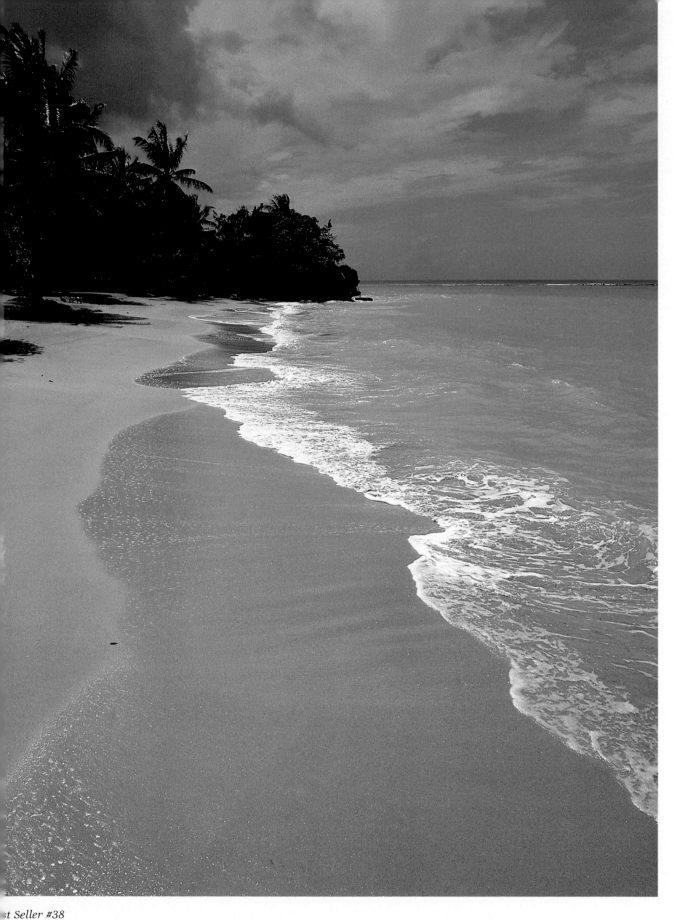

t Seller #38
al Sales: $18,207
nes Sold: 53
erage Annual Sales: $2,276
erage Sale Price: $344
hest Single Sale: $1,250

1 might think that there's an
undance of simple, serene beach
ots in stock, but, in truth, there are
y with the clarity, composition and
or of this Palm Springs vista.
ven the market demand for pictures
deal travel spots, it's no wonder
t this image is so popular.

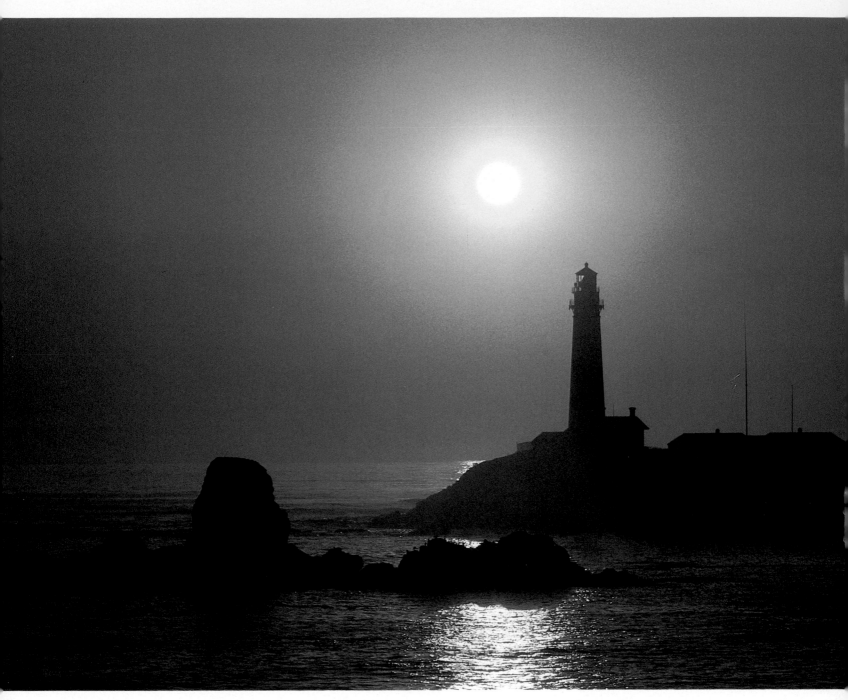

Best Seller #91
Total Sales: $10,666
Times Sold: 21
Average Annual Sales: $3,555
Average Sale Price: $508
Highest Single Sale: $950

Every day the sun rises and sets so you might think that getting this type of shot is a daily occurence. It's not. You could take your camera to the beach and spend hours—day in and day out—waiting for a sunset like this one and never see it. Sometimes with photography you just have to be in the right place at the right time with camera in hand. And you have to be quick because the conditions that will give you this photograph may only last for a moment. A bird could fly by and ruin the composition. A small, ugly cloud move in. Or a large cloud float by and hide the sun entirely.

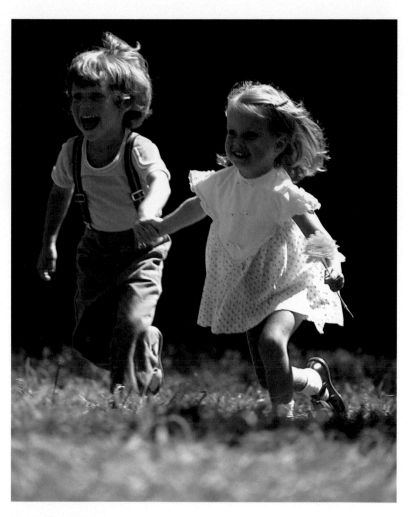

Best Seller #15
Total Sales: $27,044
Times Sold: 84
Average Annual Sales: $3,863
Average Sale Price: $322
Highest Single Sale: $1,100

This looks like a photo that any amateur could have taken, and, in fact, it has been used often to sell cameras and camera equipment. But this actually requires great skill to shoot. One must find photogenic children and a complementary, unobtrusive background. One must get the kids to perform unselfconsciously before the camera. And, when that elusive, magic moment arrives, one must be able to capture it quickly and with technical precision. All of that is accomplished in this portrait, which is why the photograph has been licensed for reproduction so often. The photographer told me that he loves to capture the magic of children on film, and when a shot is successful—as is this one—he feels particularly gratified.

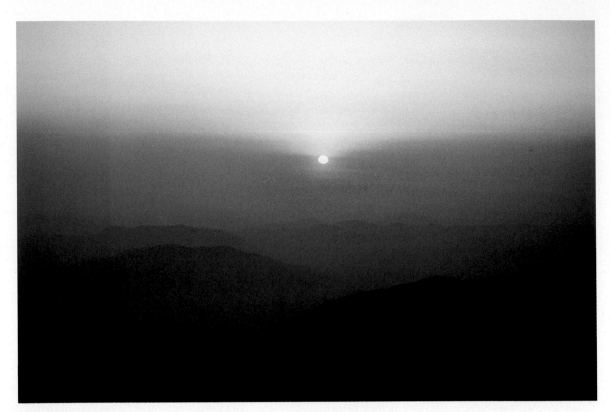

Best Seller #11
Total Sales: $29,621
Times Sold: 87
Average Annual Sales: $3,703
Average Sale Price: $340
Highest Single Sale: $2,100

"If you were standing where I was standing when I took this photo," says photographer Mark Keller, "this vista is exactly what you would have seen." Taken about 10 years ago from Palomar Mountain in San Diego county, Keller recalls, "I went there because it's a terrific place to shoot clear, dramatic sunsets. But, on this particular day, everything was very hazy and I thought I was wasting my time. Then, as the sun began to set, the haze produced a plethora of subtle tones—from blacks and purples to reds and oranges to a very pale blue and yellow. It was breathtaking. This photo has always reminded me somewhat of a Chinese painting, an art which has been a source of study and inspiration to me."

Best Seller #74
Total Sales: $11,420
Times Sold: 22
Average Annual Sales: $2,855
Average Sale Price: $519
Highest Single Sale: $750

"One day, I saw this young woman riding her magnificent white horse along Laguna Beach near my home," recalls California photographer Woody Woodworth. "Something about her poise and ease with the horse fascinated me. So, I offered to make prints for her if she would model for me and she agreed. In addition to this shot, I also photographed her jumping the horse over rocks, at the stables and in close-up." Many of those images are effective as well, but there is no denying the sense of freedom provided by this shot of a rider at full gallop just skirting the water's edge.

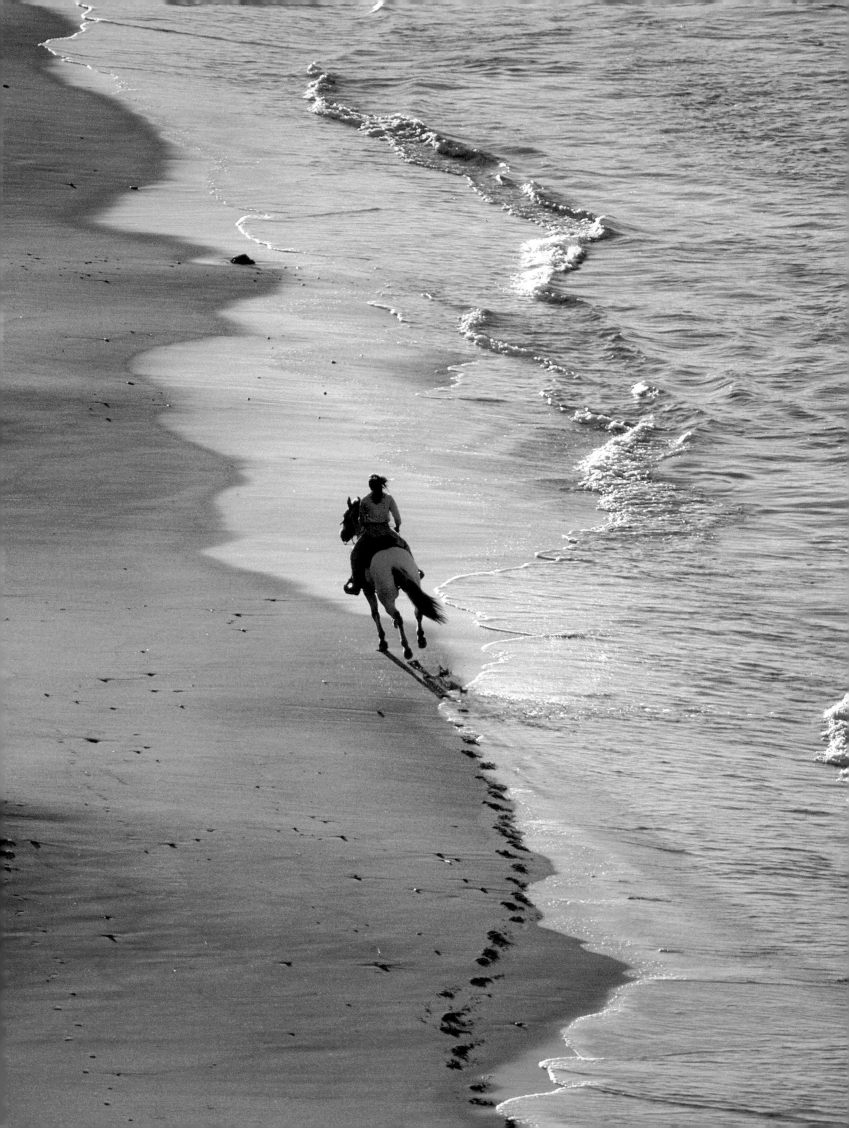

Samples of Usage

The photographer and stock agency rarely see how their photos are used, as it's not customary for clients to send samples. Over the years, we've collected perhaps five per cent of them, and a smattering are displayed here.

You've probably seen some of these photographs on book and magazine covers; in local, regional and national ads and in television commercials; in magazines, annual reports, brochures, posters, calendars, catalogs, point-of-purchase materials…in nearly every form of graphic communications. These samples only hint at the scope of usage.

#69 The subtitle of this book is beautifully illustrated by this couple who are, in fact, aging parents. *Page 63.*

#84 The helmsman is used as the embodiment for the name of a new service… Mariner. *Page 21.*

#13 One computer company used these young executives on the cover of a brochure to promote its products to the business community. *Page 54.*

#77 Some subjects do not lend themselves to a specific visual interpretation. So, this company chose a striking graphic with strong colors. *Page 58.*

#47 The soccer player makes a striking cover for a magazine directed to the teenage market. *Page 15.*

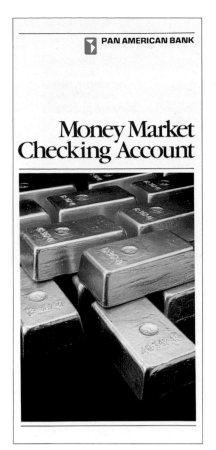

#25 An obvious choice for a bank to illustrate the growth of an interest-bearing account. *Page 19.*

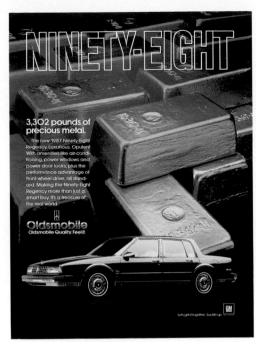

#25 A less obvious, but equally effective way to symbolize the luxury of this automobile. *Page 19.*

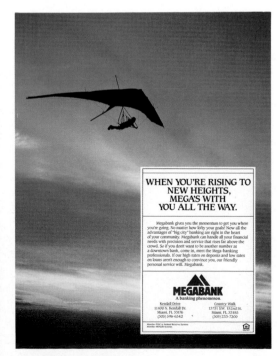

#61 The hang glider used here is surely "rising to new heights"...the theme of this ad. *Page 85.*

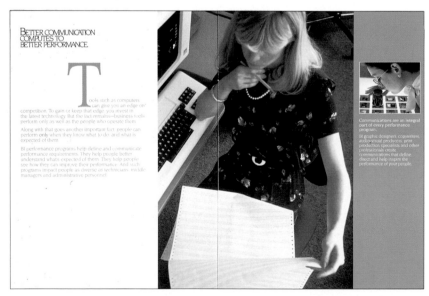

#49 This young executive at her computer was used on the cover of a brochure promoting business products. *Page 37.*

#89 What better photograph to illustrate an infant monitoring system? *Page 109.*

#86 This best-seller provides the right atmosphere for a subject that needs a delicate touch. *Page 62.*

#18 For a local banking institution's service brochure, the designer selected this happy young family. *Page 49.*

#94 This couple perfectly portrays the audience for this health plan… "active men and women." *Page 97.*

#40 The family on the beach appeared on the cover of *Reader's Digest* to illustrate "hot-weather safety tips." *Page 93.*

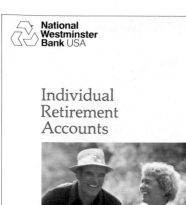

Individual
Retirement
Accounts

#5 Close cropping puts the emphasis on this couple, the epitome of happy retirees. *Page 41.*

#5 Here, the same couple is superimposed over a tranquil background to simulate the effect of the antidepressant that is the subject of this ad. *Page 41.*

We've been
protecting
people and
their property
since 1898...

#7 *(Bottom left)* Surely this cozy family scene creates the right effect for an insurance company's brochure. *Page 102.*

#58 *(Center),* #35 *(Right)* These two best sellers were used to promote a new luxurious office complex. *Page 95, 98.*

A CHRISTIAN HERITAGE CLASSIC

SPIRITUAL
AWAKENING

*Classic Writings
of the 18th Century
to Inspire the 20th Century
Reader*

EDITOR
Sherwood Eliot Wirt

#60 This best seller is perfect for the cover of an inspirational book. *Page 99.*

Photographers

SCOTT BARROW
Ten years ago, Scott Barrow left a thriving assignment photography business and sold his hundred acre farm in the Blue Ridge Mountains of Virginia to pursue a photography career in New York. While still successful as an assignment photographer in the field of advertising, Barrow most enjoys shooting on his own for stock. His photographs have been displayed at the Nikon House in New York City; Kodak's Professional Photographers' Showcase at Epcot Center, Florida; and in annual shows of the Advertising Photographers of America. *Pp. 21, 48, 82, 87, 94, 98.*

WILLIAM BEERMANN
A marketing and publishing executive, Bill Beermann is co-founder and co-president of Four By Five stock photography. He is also president of Moore & Moore Publishing, publisher of this and other photo-related books. His skills as a photographer were developed by observing other photographers at shooting sessions. Now, he is a "weekend" photographer, concentrating primarily on family subjects, including his wife, three children and parents. Beermann considers himself as a "good" amateur photographer. He just happens to have been published in over 200 publications in over 20 countries! *Pp. 67, 73, 77, 109.*

LARRY CHIGER
Larry Chiger began his professional career in the mid-'70s assisting some of New York's most successful commercial and corporate photographers. In 1978, he started his own photography business, specializing in travel and stock assignments. He expanded his professional skills to include video production, producing and directing many industrial video assignments for *Fortune* 500 companies. Presently, he is a principal in a corporate communications firm. Although he no longer accepts photography assignments, Chiger still finds time to shoot for stock. *Pp. 22, 23, 27, 52, 91.*

RON DAHLQUIST
Ron Dahlquist is an active lifestyle photographer, specializing in environmental sports activities such as surfing, skiing, windsurfing, climbing, hang gliding and any other activity that takes place at the beach or in the mountains. He has been on the staff or made contributions to many publications devoted to outdoor activities—especially those specializing in skiing and windsurfing. *Pp. 34, 55, 103.*

LARRY DUNMIRE
In his 18 years as a professional photographer, Larry Dunmire estimates that he's shot more than 80,000 transparencies. His photographs have been published in 39 magazines, on countless posters and calendars, and used as wall decor in hotels and restaurants. He lives in California but has traveled extensively in Europe, Central and South America, Australia, New Zealand, Tahiti and both the Hawaiian and Cook Islands in order to photograph his favorite subjects—travel, boating and other outdoor sports. *Pp. 53, 99.*

WILLIAM FLETCHER (1947-1983)
The late Bill Fletcher developed an interest in photography during his service as a captain in the U.S. Air Force. While he received some formal training in photography, he was essentially self-taught. He was particularly adept at photographing business and industrial subjects. *Pp. 65, 90.*

GEORGE GLOD (1945-1986)
As a high school student, George Glod was awarded an art scholarship to the Museum School of Fine Arts in Boston where he majored in photography and graphic design. After graduation, he went into package design, for which he won several awards. Next he became a creative director for *Sports Illustrated* and, later, a major cosmetics company. Glod's first real assignment as a photographer was with the Newspaper Advertising Bureau for which he traveled internationally for location shootings. He started his own commercial photography business in 1981, with major corporations as clients. While George had a real feeling for photographing people, he was equally at home shooting scenics, nature and sports with a great deal of depth and understanding. *Pp. 15, 33, 37, 45, 81, 84, 97, 107.*

MARK KELLER
A native Californian, Mark Keller is a graphic designer who works as a supervisor in the art and editorial department of a major aerospace corporation—training which provided him with a "good eye" for shooting stock photography. For the past 15 years, Keller has taken his camera and a full complement of lenses (from fisheye to super telephoto) to the tops of mountains and the depths of seas to pursue his photographic interests. *Pp. 29, 58, 85, 114.*

ROGER ALLEN LEE
Roger Lee's interest in photography began when his cousin gave him a 120 Brownie camera in 1960. Although his formal training was in industrial and graphic design, his interest in photography led him to a career as a commercial photographer on a full-time basis. Lee's photography assignments for corporate communications designers have appeared in *Communication Arts* Magazine, and have won him ten citations from art director/graphic design shows. *P. 62.*

HERB LEVART
Thirty years ago, Herb Levart had his two-year-old daughter photographed at a local portrait studio. He was appalled at the result and decided he could do better. In fact, he did so well, that a few years later he quit his job as an advertising copywriter for a career as a freelance photographer specializing in portraiture: TV performers and "anchor" people, stars of all kinds… even a U.S. President! Today Levart specializes in corporate photography for major international companies. *Pp. 17, 83.*

ROBERT LLEWELLYN
Bob Llewellyn has just completed his eleventh book, a high tech exploration of the Massachusetts Institute of Technology. His other photographic books include a trilogy on the life and philosophy of Thomas Jefferson; a photographic essay of the University of Pennsylvania; and several city books including *Washington, The Capital*, which was chosen by the State Department as an official diplomatic gift. *Pp. 18, 28, 31, 36, 38, 41, 44, 46, 49, 54, 61, 69, 70, 72, 74-75, 76, 79, 80, 89, 93, 95, 100, 102, 106, 110.*

MIA & KLAUS

Over the past 30 years, the photographs of Mia & Klaus have been featured in numerous periodicals in their native Canada and in exhibitions throughout the world. Their first book, *Bonjour Quebec*, was published in 1968; several other books on Canadian subjects followed; and their latest, a photographic album entitled *The Saint Lawrence*, was published in 1986. These veteran photographers travel extensively in their search for unusual images. *P. 14.*

CARLA MOORE

Ms. Moore was a fashion coordinator and photo stylist working in publishing, advertising and the fashion industry, and was one of the freelance fashion editors for the revitalized *Life* Magazine. She took up photography as a hobby after her marriage, becoming one of the first students of Cornell Capa's photography course at the International Center of Photography. *Pp. 35, 63.*

TSUNEO NAKAMURA

Renowned marine photographer Tsuneo Nakamura began his career in photography while majoring in coastal engineering and oceanography in his native Japan. Since then, he has photographed all of the large sailing ships around the world. Nakamura has published more than 20 books, including *The Sailing Ships of the World; The Sea Illustrated; Tall Ships;* and *Wind and Sail: A Photographic Odyssey of Square-Riggers. P. 96.*

JAMES ONG

The author is a renowned graphic designer and president of the award-winning design firm of Ong & Associates, Inc. He is also co-founder and president of Four By Five, the stock photo agency featured in this book. Unlike his best seller in this book—taken on vacation in 1975—most of Ong's photo concepts are executed by his New York City studio staff. *P. 71.*

GRAEME OUTERBRIDGE

Graeme Outerbridge is a native of Bermuda where he has won numerous awards for artistic achievement. His work has been exhibited in galleries in New York, Washington, D.C., Boston, London and Helsinki, and has appeared in such publications as *The New Yorker* and *Vogue.* He has published one book, *Bermuda Abstracts* and is working on another on the subject of bridges. Outerbridge was one of the featured photographers in the book *A Day in the Life of America. P. 42.*

BO RICHARDS

Bo Richards was introduced to photography by the late Ron Church and assisted him in photo assignments for Time-Life Books, *National Geographic* and Ivan Tors Films. She co-authored the book *Secrets of the Sea.* Her photographs have appeared in numerous publications and on posters, greeting cards and magazine and textbook covers. *P. 43.*

PABLO RIVERA

Pablo Rivera began his career as a graphic artist for a New York design firm in the 1960s. He became that company's staff photographer in the '70s, later becoming its Director of Photography. Rivera has conducted photography workshops and exhibited in galleries in New York City and on Long Island. His work has been published in *Photographics, Graphis* and *The One Show Directory. Pp. 19, 47, 56, 64.*

MICK ROESSLER

Mick Roessler's photography reflects his deepest interests—nature, fishing, boating, travel, outstanding scenery, among many others. He is a good "people" photographer as well, photographing them at work and at play. Roessler has traveled and photographed extensively throughout the United States and in 52 foreign countries. With 35 years of photographic experience to his credit, he has amassed a collection of well over 200,000 color transparencies. *Pp. 40, 57.*

TOM ROSENTHAL

Tom Rosenthal abandoned his premed studies to travel to Europe, Africa and the Middle East, where his desire to record his experiences developed into an interest in photography. He returned to the U.S. to resume his studies, this time as the first "independent major" at the State University of New York, Buffalo, concentrating on courses in art and documentary photography, video tape and film, and foreign languages. Rosenthal pursued a career in assignment photography in Europe. When he returned once again to the U.S., it was to become a stock photographer—one of the first. *Pp. 16, 20, 26, 30, 39, 50-51, 66, 68, 78, 101, 105, 111, 113.*

CONRAD SIMS

As a 16-year-old high school student in Cleveland, Ohio, Conrad Sims won the National Scholastic Photography Award. Today, he lives in New Zealand where he continues his career in photography, specializing in architectural, industrial and agricultural subjects. He has four books to his credit, with two new collaborations to be published this year. *Pp. 86, 104.*

STEVE VIDLER

A native of Dover, England, Steve Vidler travels 12 months out of the year, taking photographs exclusively for stock. He has visited more than 50 countries, staying no longer than two or three weeks in any one place. He is considered one of the world's most successful stock photographers. Vidler has recently published a book in Japan entitled *Asians in Focus. Pp. 24, 92, 108.*

FRANK WOOD

Frank Wood started his photographic "career" in high school with a borrowed camera. Years later, after earning an MBA, he used his photographic skills on a freelance basis for the greeting card market. He traveled internationally as an executive with a major corporation, taking photos wherever he went. Now, back in the U.S., Wood has resumed shooting for greeting card, calendar and stock photography markets. *P. 32.*

WOODY WOODWORTH

His love of surfing and the ocean compelled Woody Woodworth to capture on film the many scenes he saw at the shoreline. He is listed on the masthead of *Surfer* magazine, to which he contributes extensively. His work has also been exhibited and sold as prints at art shows, where he has won many awards. Woodworth has also been involved in coordinating and designing photo mural interiors for offices and restaurants. His outdoor expertise has extended his talents to include active wear fashion photography. *Pp. 60, 88, 112, 115.*

Index of Best Sellers